Andy Warhol

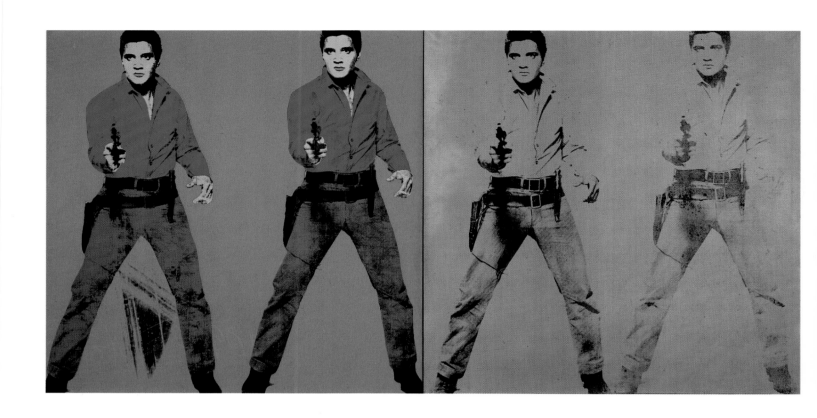

Klaus Honnef

ANDY WARHOL
1928–1987

Commerce into Art

Benedikt Taschen

COVER ILLUSTRATION:
Detail from: Elvis I and II, 1964
Left panel: silkscreen on acrylic on canvas,
208.3 × 208.3 cm
Toronto, Art Gallery of Ontario,
Gift from the Women's Committee Fund, 1966

FRONTISPIECE:
Elvis I and II, 1964
Left panel: silkscreen on acrylic on canvas
Right panel: silkscreen on aluminium paint on canvas
Each panel: 208.3 × 208.3 cm
Toronto, Art Gallery of Ontario,
Gift from the Women's Committee Fund, 1966
(Photo: Powey Chang, AGO)

BACK COVER:
Andy Warhol, 1974
© Photo: Helmut Newton

**This book was printed on 100 % chlorine-free bleached
paper in accordance with the TCF standard.**

© 1993 Benedikt Taschen Verlag GmbH
Hohenzollernring 53, D-50672 Köln
© Translated from the German by Carole Fahy and I. Burns
for Bookdeals Translations 5, Mill Hill Alresford SO 24 9 DD, England
© Illustrations: The Estate of Andy Warhol, New York 1988
Edited by Angelika Muthesius
Cover: Angelika Muthesius

Printed in Germany
ISBN 3-8228-0565-3
GB

Contents

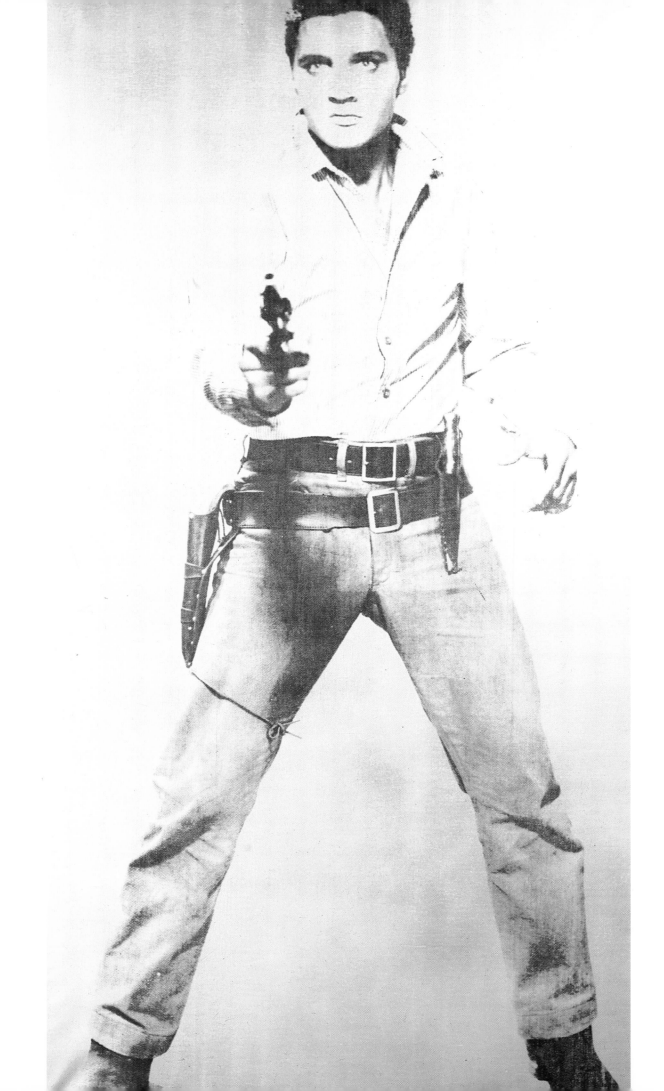

Andy Warhol
First Pop Star of the Art World

He was a legend in his own lifetime. Hardly anyone's life has been covered by as much writing (and gossip) as has Andy Warhol's. The pages written about his life and work, if laid end to end, would reach half way round the world. Sometimes, when he appeared in public, he gave the impression of not being of this world. Shy, friendly and usually smiling, part of him always seemed to be somewhere else. But he was the personification of the American Dream – with a career which spanned washing dishes to becoming a millionaire (although, of course, he never actually washed dishes). His was the archetypal rags to riches story. His date of birth is the subject of some controversy: different dates can be found in various publications, but it does seem fairly certain that it occurred between 1928 and 1931. Andy Warhol himself claimed that his 1930 birth certificate had been forged and June 6, 1928 is the date most frequently taken as his birthday. There are even two versions (at least) of the date of his death in circulation, but it seems certain that he died on February 22, 1987 as the result of gall bladder surgery. His birthplace was Forest City, Pennsylvania and he was christened Andrew Warhola.

It is difficult to find out the truth about the life of Andy Warhol (the name he took after he moved to New York in 1949). Contradictions seem to have been his life's elixir, the veiling of biographical and other personal facts the means he used to create a mystery around himself. He had been trained as a commercial artist – he saw himself as a "pure" artist – but he had in fact created a completely new type of artist, which irritated, shocked and changed the world of art – although various aspects of the practice of his art are firmly reminiscent of the practices of artists of the Renaissance and Baroque periods. He was reserved with journalists and was clearly never comfortable being interviewed. During an interview for the German weekly illustrated magazine *Stern* (October 8, 1981) a journalist commented: "It is not fair to make Andy Warhol give this interview. He is suffering. He doesn't want to open up." Yet, no other artist of his time has left us with as many maxims as he did. As well as an abundance of interviews and aphorisms he left us two autobiographies, although nobody can say for sure who actually wrote these books, Warhol himself or one of his numerous ghost writers.

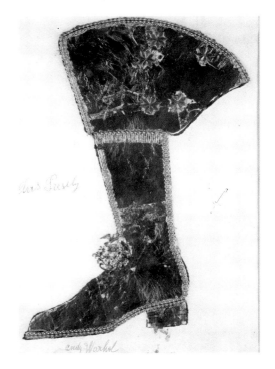

Golden Boot Elvis Presley, 1956
Collage, blotted line and golf-leaf,
52.7 × 37.5 cm
New York, Tom Lacy Collection

OPPOSITE:
Single Elvis, 1964
Silkscreen on canvas, 210 × 105 cm
Neue Galerie – Ludwig Collection, Aachen

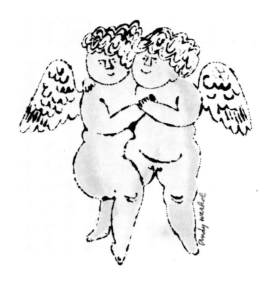

Two Cupids
Blotted line and watercolour on paper,
24.4 × 22.6 cm
Bremen, Michael Becher Collection

Judy Garland, 1956
Collage, blotted line and gold-leaf,
51.2 × 30.4 cm
Bremen, Michael Becher Collection

Though he hardly ever missed out on any party or public event within his reach, he loved to be represented by a double. "Andy" was seen everywhere and in the land of unlimited opportunities and vast distances the use of a double was hardly ever noticed. The truth did occasionally come to light, though. The first time was on an occasion when Warhol was celebrating his first commercial success as a film maker with *The Chelsea Girls.* Subsequently, having given several lectures at various American colleges, he became bored and handed the job over to Allen Midgette, who passed himself off as Warhol. The result, in both cases, was uproar! Warhol was easy to impersonate, as he often hid behind dark glasses, under a white wig and had a very distinctive appearance with his big head and his pensive smile – even before he became fully established in New York, he had started dyeing his hair blond.

Andy Warhol was a dedicated and enthusiastic admirer of both film stars and the contemporary cult figures of North American literature. He collected their autographs and even wrote to Truman Capote, the pet of the New York culture scene, who, however, did not favour him with a reply. The superstars he depicted, however, were to replace the stars of the heroic phase of American films, themselves to become threatened by megastars, overnight celebrities of the world of the media. Warhol's motto "Famous for 15 minutes" – thanks to the instant communications of our times – has become reality for many.

Andy Warhol was the embodiment of the new kind of star. Creator, producer and actor in one, he enriched the world by providing us with an idol from the world of art. A good businessman, he marketed his quality of elusiveness as well as marketing himself in his role as head of his studio of 18 employees ("the boys and girls"). It has been said of Andy Warhol that "art gained beauty primarily through money." A friend and sponsor of his early days, Henry Geldzahler, praises the artist's fascinating combination of business and art. Sociologist and film maker Edgar Morin observed that we project any number of needs and desires that cannot be fulfilled in real life into the exalted, mythical being (of the star); he thus defines the most important socio-psychological requirement in the creation of the 20th century cult of the film star, pop star, etc. The idol appears unreal, an apparition made from light and shade. The cult of the 'star' is not really meant for a human being of flesh and blood – his physical presence merely affords proof that this apparition does indeed exist. No one saw through the mechanism of the 'star' cult better than Andy Warhol himself, as is illustrated by his public appearances. With the trick of being physically present and at the same time in another world, he seemed to be a physical apparition. For Henry Geldzahler the main reason for Andy Warhol's fabulous success lies in this ability. According to Geldzahler, thanks to Warhol's appearance as a "dumb blond," it was not long before the public began to identify him with the Pop movement. And, as he put it, there have indeed been very few artists – Pablo Picasso, Salvador Dalí, Jackson Pollock – in this century who have come to be

8

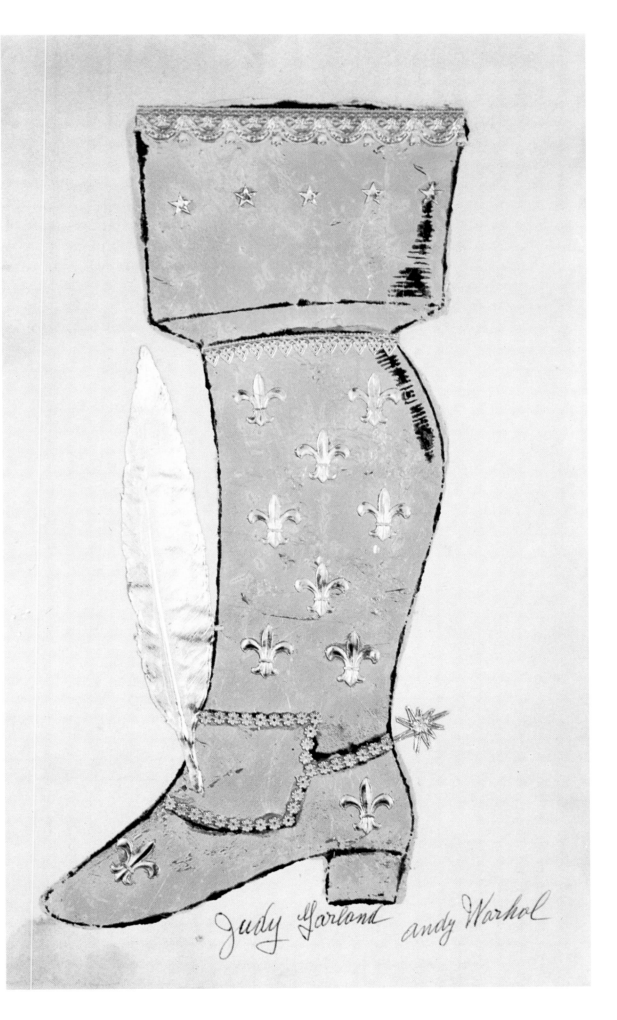

Judy Garland andy Warhol

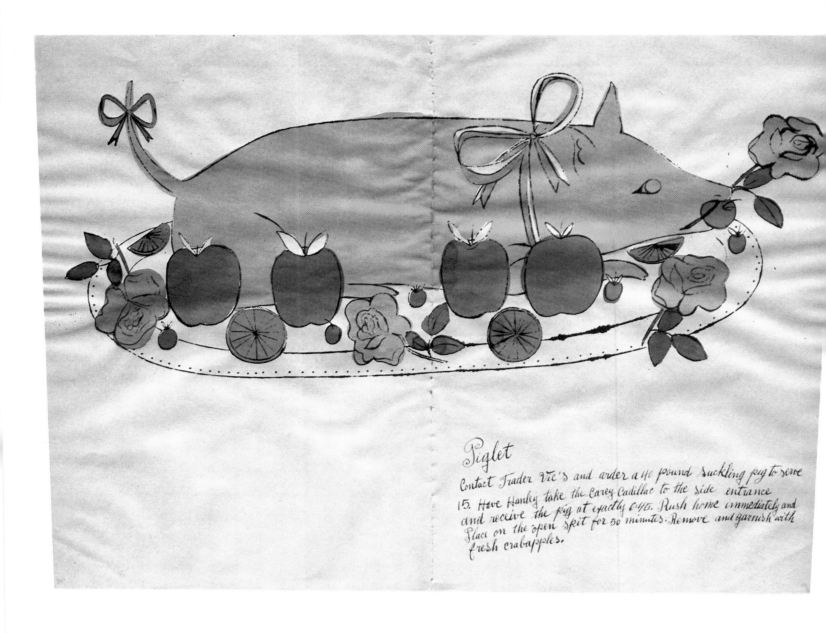

Piglet

Contact Trader Vic's and order a 40 pound suckling pig to serve 15. Have Hanley take the Carey Cadillac to the side entrance and receive the pig at exactly 6.45. Rush home immediately and place on the open spit for 50 minutes. Remove and garnish with fresh crabapples.

Piglet, 1959
Watercolour and blotted line on paper,
44.5 × 28.6 cm
Double-page from *Raspberries*,
published by
Andy Warhol and Suzie Frankfurt,
New York 1959

recognized by the man on the street in America. Marilyn Monroe, Warhol's favourite model, was also a different kind of "dumb blonde" (pp. 14, 15, 17). But in contrast to her portraitist she was always flesh and blood, even though only a comparatively small number of people actually saw her in person.

Only the screen granted her the status of sex-goddess. What films did for the Hollywood stars – from Mary Pickford (the first star who truly deserved the name) through Charlie Chaplin, Greta Garbo, Marlene Dietrich, Mae West, Bette Davis, Clark Gable and Humphrey Bogart to James Stewart, Ingrid Bergman, Elizabeth Taylor and Marilyn Monroe – the tabloid newspapers did for Andy Warhol by fictionalising reality. He took advantage of their romanticising (which in the Sixties was all the rage), spread and to a certain extent created by the triumphant advance of television. The borders between reality and imagination were slowly being eroded. The television documentary – seemingly reality but able to create a fictional result – demonstrated its power for the first when the Kennedy-Nixon debates were fought out in front of the cameras. Even though the actual impact of

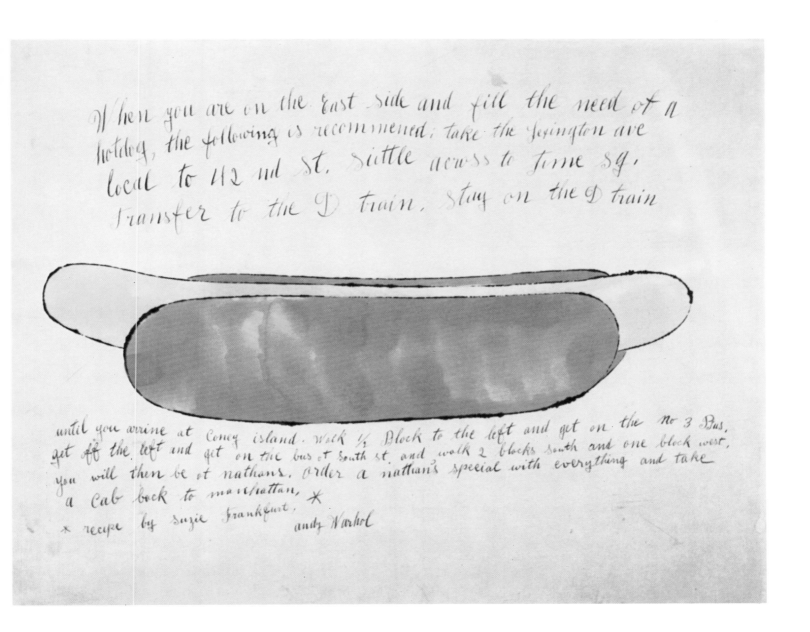

When you are on the East side and fill the need of a hotdog, the following is recommened; take the Lexington ave local to 112 nd St. siuttle acwss to Time Sq. Transfer to the D train. Stay on the D train until you arrive at Coney island. Walk ½ Block to the left and get on the No 3 Bus, get off the left and get on the bus at south St. and walk 2 blocks south and one block west, you will then be at nathans. order a nathan's special with everything and take a cab back to marshattan, *

* recipe by Suzie Frankfurt.
andy Warhol

Hot Dog, 1957/58
Blotted line and watercolour on paper,
51 × 76 cm
Bremen, Michael Becher Collection

this historic media event on the outcome of the American presidential elections is still disputed, television has, ever since, played a ruling part in election campaigns all over the world. In the United States, in particular, a political candidate has to be 'telegenic' to have any chance of success.

Andy Warhol had chosen Marilyn Monroe as his model after her death; death had set the seal on her supernatural existence (pp. 14, 15, 17). Apart from Humphrey Bogart she appeared to be the only film star whose posthumous fame exceeded by far her popularity in her own lifetime. Andy Warhol certainly contributed his part to this. What actually drew his attention to the screen sex bomb (at that time the throne of sex-goddess was still reserved for Rita Hayworth and was only awarded to Marilyn Monroe long after her death) is hard to determine. With hindsight, this decision illustrates Andy Warhol's infallible ability to nose out trends. Surely, it was not just the actress's sex appeal which was the deciding factor. Was it possibly the legend that had been woven around her? Film historian Enno Palatas wrote that Marilyn Monroe had fashioned a legend about her youth to suit

Questions all America is asking, 1953
Two colour jacket of a TV programme for NBC on public issues
Illustrated in *Graphics Annual* 1953/54, p. 112

OPPOSITE:
Triple Elvis, 1964
Silkscreen on canvas, 209 × 152 cm
New York, private collection

her tastes, claiming that her parents used to beat her with a leather strap, that she was raped by a "friend" of the family when she was six years old, and then was juggled back and forth by unloving step-parents; and although journalist Ezra Goodman was later able to disprove this story, it fitted so well with her image that people still liked to believe it.

Elvis Presley and Elizabeth Taylor were two other idols captured by Andy Warhol's art in numerous pictures and picture series (pp. 6, 13, 19), even if not to the same extent as Marilyn Monroe. For all their differences these stars have one thing in common: they are the personification of the American success story. Norma Jean Baker, alias Marilyn Monroe, went from mistreated child – if one wants to believe the legend – to celebrated sex symbol. Elvis Presley went from singing truck driver to become the celebrated idol of a whole generation, and Elizabeth Taylor, who started as a child film actress, one of Hollywood's most highly paid stars. They were all, too, surrounded by a hint of tragedy – Marilyn Monroe tried, desperately and in vain, to rid herself of the stereotype image of the dumb blonde sex symbol; Elvis Presley frequently fell into fits of depression; and Liz Taylor constantly struggled with health problems.

It is not the least surprising that Andy Warhol identified, in part, with these stars. The cult of success is the bond that unites the whole country of the United States of America. Andy Warhol wanted to be one of its High Priests. He himself determinedly created his own legend. He once spread a story that his father had been killed in a mine. In this context he even travelled to Pittsburgh, capital of the North American coal and steel region, near where he was born. A famous film documents this gloomy, dirty and violent region: Michael Cimino's *The Deer Hunter.* The picture it created of the heart of the American steel industry was as inauthentic as Andy Warhol's make-believe. Warhol's father did indeed work in a mine, but in the coal mines of West Virginia, which gave him little time at home. Andy and his brothers grew up under the care of their mother. In 1942 his father died, but after a long illness resulting from drinking poisoned water. Warhol's parents had originally emigrated from Czecho-slovakia to the United States, his father in 1909 – some say 1912 – to evade military service in his homeland and his mother following nine years later. After his father's death the Warhola family made a bare living on the edge of absolute poverty. During school holidays Andrew sold fruit and helped out as a window-dresser. A photograph taken in 1941 shows him as an introverted, slightly dreamy-looking pretty blond boy.

"I had had three nervous breakdowns when I was a child, spaced a year apart. One when I was eight, one at nine, and one at ten. The attacks – St. Vitus Dance – always started on the first day of summer vacation. I don't know what this meant. I would spend all summer listening to the radio and lying in bed with my Charlie McCarthy doll and my un-cut-out cut-out paper dolls all over the spread and under the pillow. My father was away a lot on business trips to the coal mines, so I never saw him very much. My mother

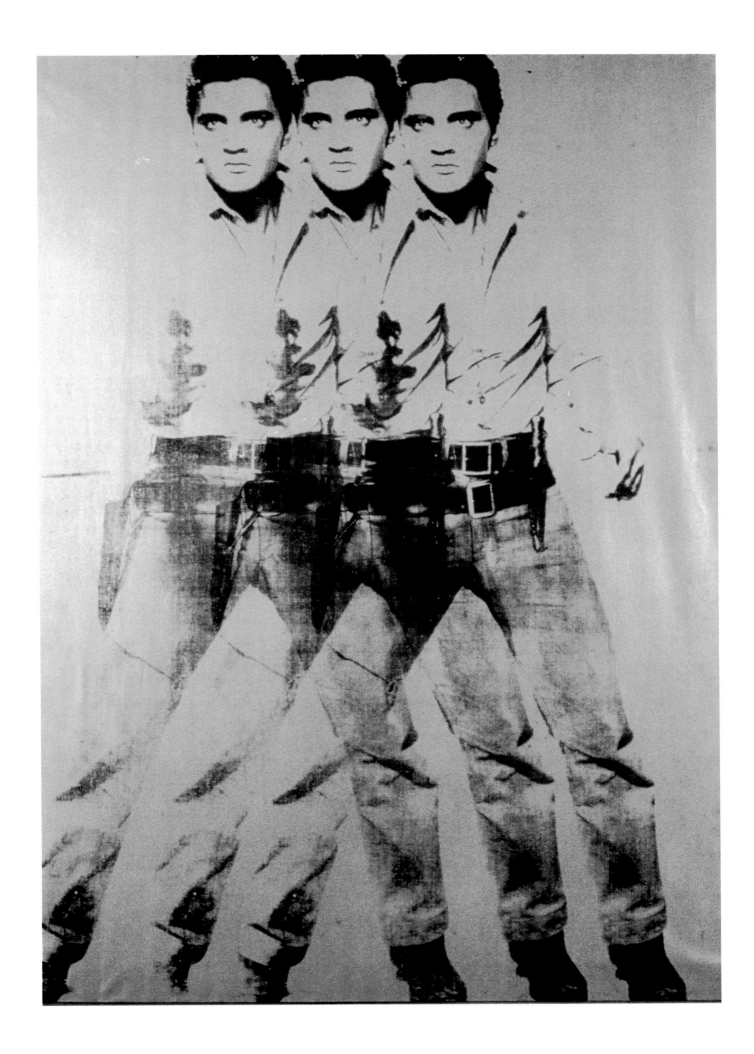

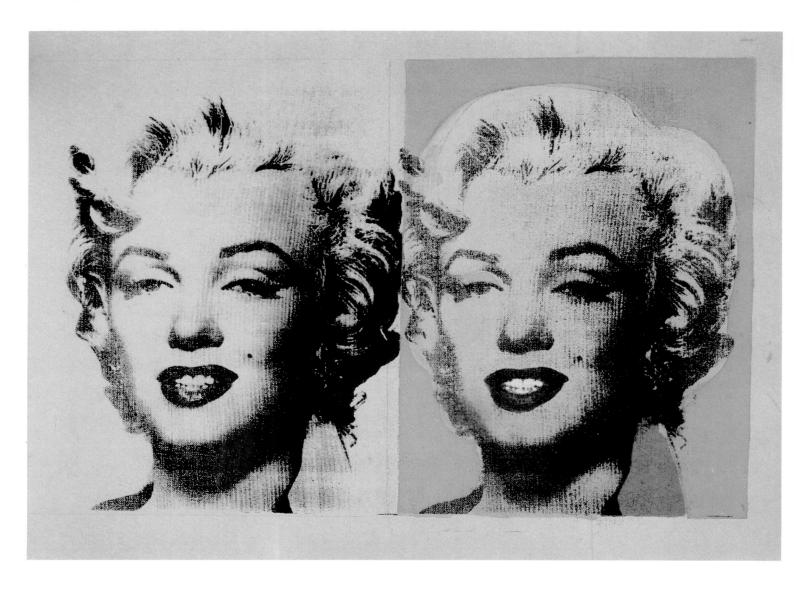

The Two Marilyns, 1962
Silkscreen on canvas, 55 × 65 cm
New York, private collection

would read to me in her thick Czechoslovakian accent as best she could and I should always say "Thanks, Mom", after she finished with Dick Tracy, even if I hadn't understood a word. She'd give me a Hershey Bar every time I finished a page in my coloring book."

The stuff of which legends are made. At that time the United States was still in the process of recovering from the far-reaching consequences of the Depression. The advance of the Nazis through Europe and the crushing Japanese attack on the American Pacific Fleet in Pearl Harbor now forced the United States into a world war which also demanded its victims among civilians.

In the department store where he worked during his summer holidays Warhol came into contact for the first time with the world which was later to become his own specific world – the world of consumer advertising. As the son of European immigrants, with a mother who never mastered the English language, his early years were filled with his family's stories – memories of the Old Country. Later on as a student in America he was to wander "through the Czech ghetto with the babushkas and overalls on the clotheslines." These years were to give him a thorough understanding of the true nature of America. Here at the department store he was surrounded by a glamorous world which was completely out of his reach. "I had a job one summer in a department

14

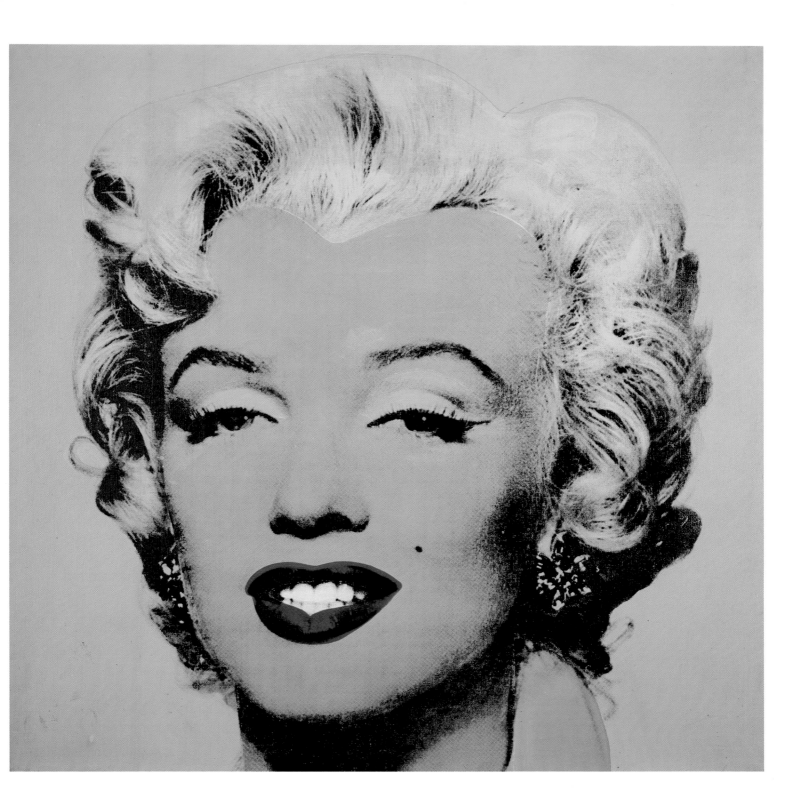

Marilyn, 1964
Silkscreen on canvas, 101.6 × 101.6 cm
Reproduced by kind permission of
Thomas Ammann, Zurich

store looking through *Vogues* and *Harper's Bazaars* and European
fashion magazines for a wonderful man named Mr. Vollmer. I got
something like fifty cents an hour and my job was to look for 'ideas.' I
don't remember ever finding one or getting one. Mr. Vollmer was an idol
to me because he came from New York and that seemed so exciting. I
wasn't really thinking about ever going there myself, though." When he
finally moved to New York it was Carmel Snow, legendary editor of
Harper's Bazaar, who helped him most when he first arrived.

 While studying at the Carnegie Institute of Technology in Pitts-
burgh, he met Philip Pearlstein, a well-known American painter of

Reversal Series: Marilyn, 1979–1986
Silkscreen on canvas, 46 × 35 cm
Salzburg, Thaddaeus Ropac Gallery

nudes, and spent a lot of time with him. His teachers do not remember anything remarkable about the young student. Robert Lepper, who, according to Pearlstein, was "the only really good teacher" at the Carnegie Institute recalls that Warhol was a skinny little boy whom he did not know particularly well; but he said Warhol did his work and some of it really was very good. Though Pittsburgh was provincial it enjoyed a lively political and cultural scene. Philip Pearlstein remembers Andy Warhol's interest in dance, and in artists such as the American dancer José Limón, who was a kind of hero in the cultural scene back then; Pearlstein remembers that he and Warhol always went to his performances. He also remembers Martha Graham's troupe, and her special technique. He thought that in some ways Martha Graham was like Bertolt Brecht; they had heard of Brecht's theory and technique of epic theatre and of the alienation effect. Warhol finished his studies with a B.A. in Fine Arts and soon after left Pittsburgh. His student years were over.

His move to New York marked the beginning of his years of travelling. He shared a studio with Pearlstein at St. Mark's Place on the Lower East Side, home of many of the has-beens of the New York literature and music scenes (later, in the Eighties, to become the home of Graffiti). "When I was eighteen a friend stuffed me into a Kroger's shopping bag and took me to New York", was Warhol's laconic comment on this decisive step (according to Rainer Crone, he was 21 at the time).

For Europeans, New York – the noisy metropolis with its electrifying atmosphere and hectic lifestyle – is synonymous with America. Although Eugene Rosenstock-Huesy, philosopher and sociologist, sneeringly remarks that few Americans would be interested if it were destroyed by an atom bomb, for Warhol, son of immigrants from central Europe, New York became the apotheosis of all his desires: Fifth Avenue with its elegant shops, Madison Avenue, centre of advertising and the El Dorado of the commercial arts, Park Avenue with its exclusive apartment blocks. Though he observed this life from a distance, he saw it with the eye of a stranger who notices things which the New Yorker takes for granted. He first started working as a professional graphic designer, creating advertisements for fashion magazines like *Glamour, Vogue* and *Harper's Bazaar* and this was when he changed his name to Andy Warhol. Several times he changed apartments and studios looking for friends. "I kept living with roommates thinking we could become good friends and share problems, but I'd always find out that they were just interested in another person sharing the rent." His success came relatively quickly and the "American Dream" of unstoppable success came true faster than he had expected.

The story of his rise to fame is dotted with anecdotes. Calvin Tomkins, art critic, tells us how Tina Fredricks, then art director of *Glamour*, contributed to them. She was thrilled by Andy's drawings but could not find a commercial use for them. She told him that the drawings were good, but that *Glamour* could only use drawings of shoes at the moment. The next day Warhol came back with 50 draw-

16

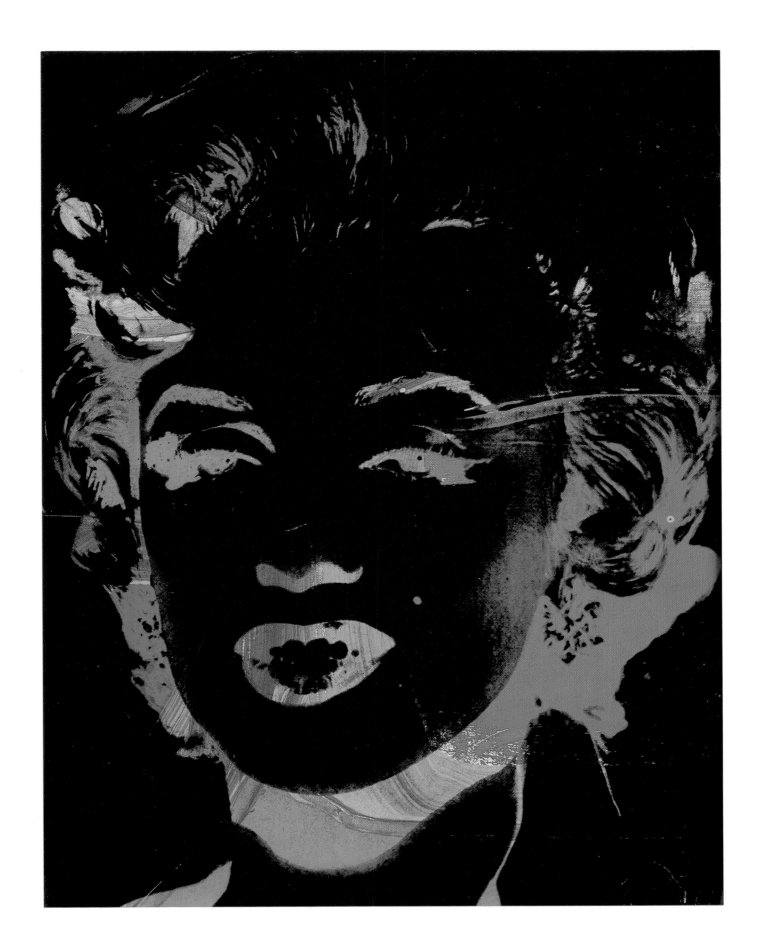

ings of shoes in his brown paper bag. No one had ever drawn shoes the way he did.

Footwear was to be a recurring theme in his work up to the early Sixties and many see this as the most important era of his commercial phase. Tomkins praises the subtlety of these drawings which were done in the style of Toulouse-Lautrec and admires their empirical exactness. "Each buckle was in the right place." His creative series, *Golden Shoes*, each devoted to film stars such as Mae West, Judy Garland (p. 9), Zsa Zsa Gabor, Julie Andrews, James Dean and Elvis Presley (p. 7), to authors such as Truman Capote and to the transvestite Christine Morgan, were received with approval. He even devoted one set to Margaret Truman, pianist daughter of President Truman. Sometimes part of a leg could be seen in a shoe, as in the Mae West series, but in general these gold-plated profiles of footwear, intended to represent the stars themselves, were unadorned by any unnecessary additions. The Madison Avenue exhibition of 1956 displayed the complete series of *Golden Shoes* – a rewarding field for the attentions of any interested psychologist!

One is taken aback by the fact that Warhol identifies a product with a real person, a film star. His idea – which never came to fruition – of selling film stars' underwear washed at $ 5, unwashed more expensively, underlines his undisguised fetishism. But his gentle approach through his drawings to the magic world of the 'stars' is more remarkable even than the underlying sexual tension of this series of pictures.

Window-dressing for Bonwit Teller, New York, April 1961
In the background hang paintings by Andy Warhol, from left to right:
Advertisement, 1960; *Little King,* 1960; *Superman,* 1960; *Saturday's Popeye,* 1960

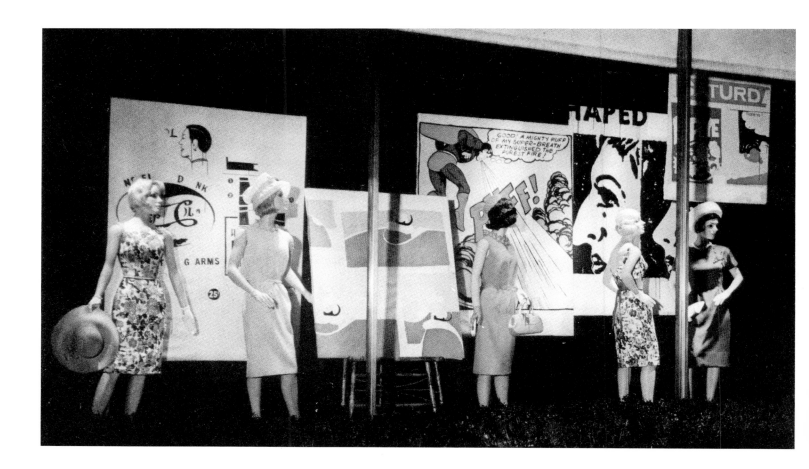

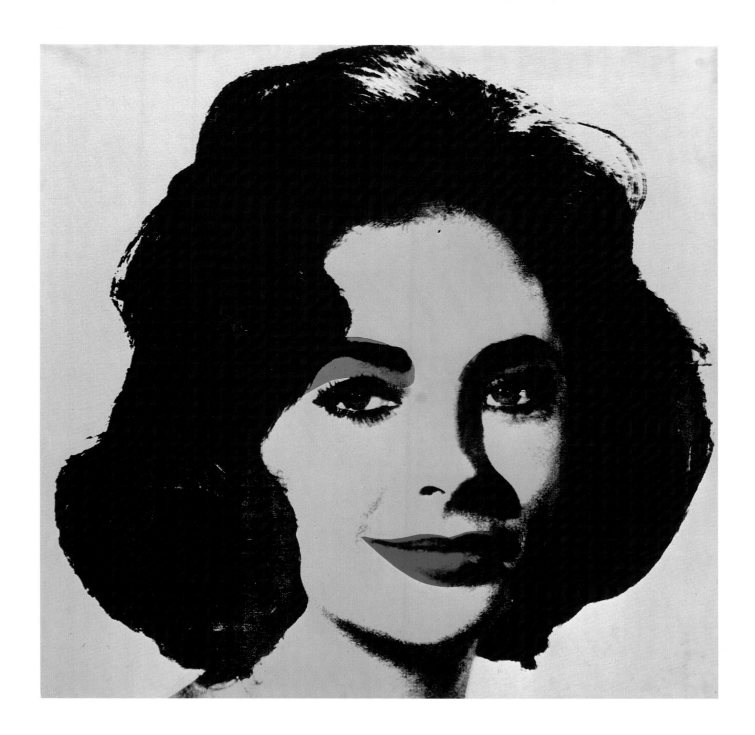

Liz, 1965
Silkscreen on canvas, 106 × 106 cm
New York, private collection

According to Rainer Crone, any traces of the real Warhol — the artist — are lost in a jungle of anecdotes and tales. Art critics consciously wove a mystery around his life and work and reduced his personality to useful proportions in order to play down the uniqueness of his art. But Andy Warhol himself was the original source of the tales that surrounded him — and for a very good reason: you can only become a star if everybody is talking about you. Warhol never lost sight of his actual goal: being an artist and — though he never said so — of being a star, according to Henry Geldzahler, his friend from early days.

Campbell's

CONDENSED

TOMATO
SOUP

The Road to Fame
From Commercial Artist to Celebrated Pop Artist

In spite of his growing success in the world of advertising and glitter, he still wanted to be recognised as an artist, as a "pure" artist whose pictures would stand as a monument to himself and would increase, or even exceed, the value of the goods he portrayed. It is a well-known fact that Warhol used to hide his commercial paintings when visited by art collectors, for even in New York in the 1950s, commercial art stood for bad taste, routine, mass production and mechanisation. For was it not the opposite of 'true' art which was the mirror of our souls and hearts, felt, not fabricated, eternally dedicated to truth? Warhol was probably aware of this in the early stages of his success, but even after his breakthrough as a true artist he maintained a separate studio for his commercial work next door to his creative studio. The fact that his commercial studio was soon to take over the task of promoting all his works proves both his intelligence and his sensitivity to the values of the art world.

He made several attempts at change, but Warhol was empirical if nothing else and could not alter his style even in the Fifties, the era of the undisputed rule of Abstract Expressionism in the United States. The paintings of such artists as Jackson Pollock, Franz Kline, Clyfford Still, Mark Rothko and Barnett Newman were celebrated for their introspective and extravagant idealism and were part of the spread of American cultural thought and movement which strictly rejected the physical and material. Neither the artistic influences that his teachers at the college in Pittsburgh had conveyed nor those he picked up and absorbed during his first years in New York – from the art of Rubens and Courbet to American folk art – gave him the inspiration he hoped for. On the other hand, he gained growing recognition for his designs for sophisticated advertisements which appeared in the glossy high fashion and luxury magazines. Calvin Tomkins said that no matter what he illustrated, be it shampoo, lipstick or perfume, there was a certain decorative originality to his work that made one notice it. The childlike hearts and androgynous pink-coloured angels he employed had a slightly suggestive effect that people in the now recognized and liked (cf. p. 8). Warhol acquired the technique of direct reproduction in order to produce his designs: with pencil he drew his design on waterproof paper, then

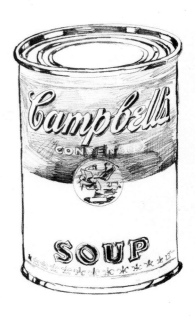

Large Campbell's Soup Can, 1962
Pencil on paper, 60 × 45 cm
Private collection

OPPOSITE:
Campbell's Soup Can I, 1968
Acrylic and liquitex, silkscreen on canvas,
91.5 × 61 cm
Neue Galerie – Ludwig Collection, Aachen

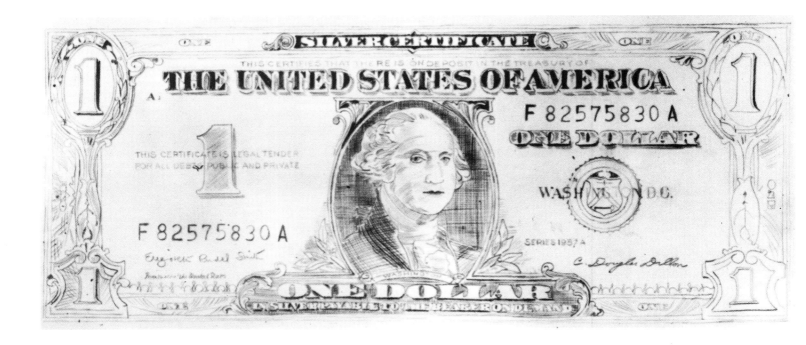

One Dollar Bill with Washington Portrait, 1962
Pencil on paper, 45 × 60 cm
Private collection

OPPOSITE:
Two Dollar Bills (front and rear), 1962
Silkscreen on canvas, 210 × 96 cm
Cologne, Museum Ludwig

followed the outline in ink and printed it on absorbent paper while still moist. This technically primitive technique, no more than a simple blotting-paper technique, was distinctly effective. The lines looked sketchy, light and floating, as in print they did not appear as solid lines, but were partially interrupted, sometimes strong, sometimes weak, sometimes more accentuated. Because he put a lot of care into the first drawing, the result was an ensemble of lightly blotted and yet continous lines and familiar – but at the same time slightly defamiliarized – shapes. Once the work was printed, Warhol (or one of the assistants, who had started gathering around him very soon after his first success) coloured in the various parts using pastel colours, pink, light blue, or pistachio green or bright orange. Warhol also used this technique of the "blotted line" to produce his creative works, e.g. book illustrations that he printed in a limited series of 100 copies at Seymour Berlin in New York at his own expense. The comments and notes to these, done in childish handwriting, are his mother's work (pp. 10, 11). These prints were to help him gain a foothold in the art world. They were shown in rented art galleries – e.g. at the Hugo Gallery in June 1952, in a one-man exhibition, according to certain biographers, in a group exhibition, according to others – but they did not gain much recognition. James Fitzsimmons remarked in *Art Digest* magazine that Warhol's fragile impressions reminded him of Aubrey Beardsley, Henri de Toulouse-Lautrec, Charles Demuth, Balthus and Jean Cocteau; they showed a touch of 'preciousness,' of carefully studied perversity; his best pictures conveying difficult-to-comprehend and ambiguous feelings.

His "blotted line" technique is seen by many as one of the decisive steps in his artistic development. As he printed the ink outline he multiplied the initial drawings and thus devalued the term "original," one of the sacred tenets in the history of art. On the other hand, his unusual – or rather unused – technique cannot be seen as a revolutionary invention, as it does not entirely deviate from the old

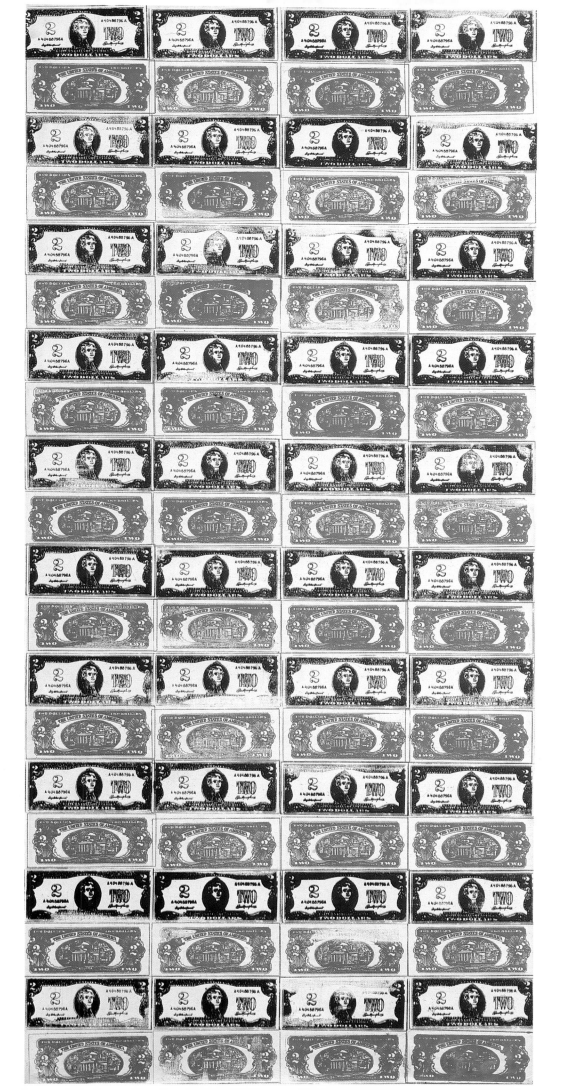

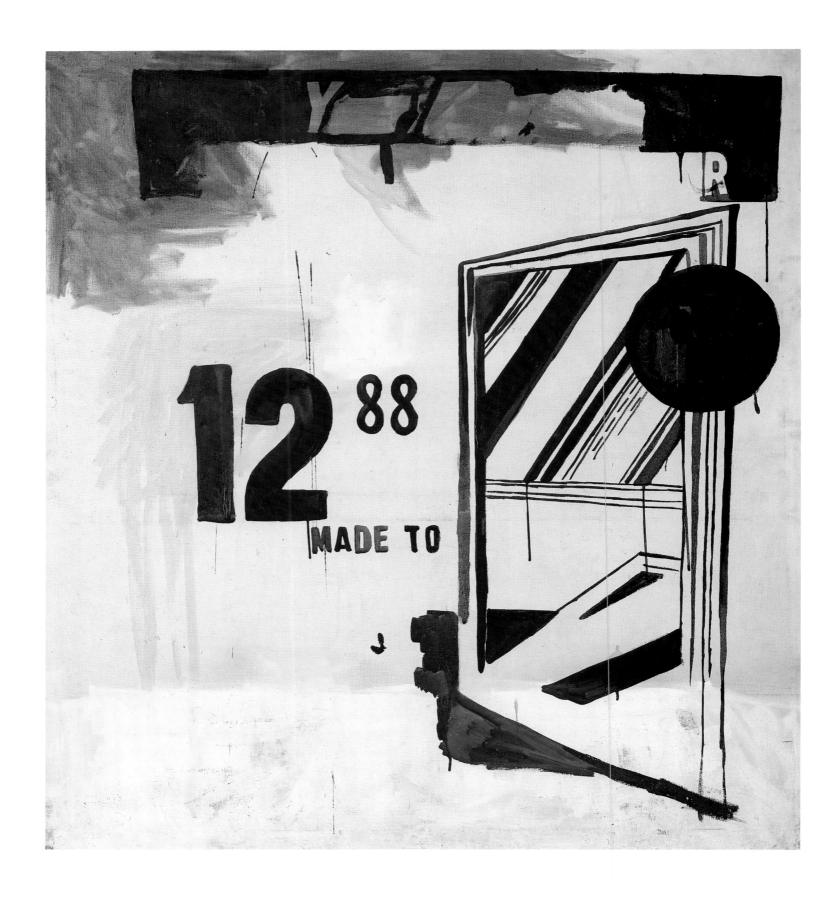

Storm Door, 1960
Acrylic on canvas, 117 × 107 cm
Reproduced by kind permission of
Thomas Ammann, Zurich

artistic reproduction techniques, such as woodcut, copperplate
engraving, etching or lithography; and yet, the idea that uniqueness
(as distinct from soleness) is the compelling determination of a work
of art remains unaffected by the blotting-paper technique. Warhol's
subversive attack on the doctrine of the original had really consisted
in the fact that he only rarely did any work himself on the mock-

24

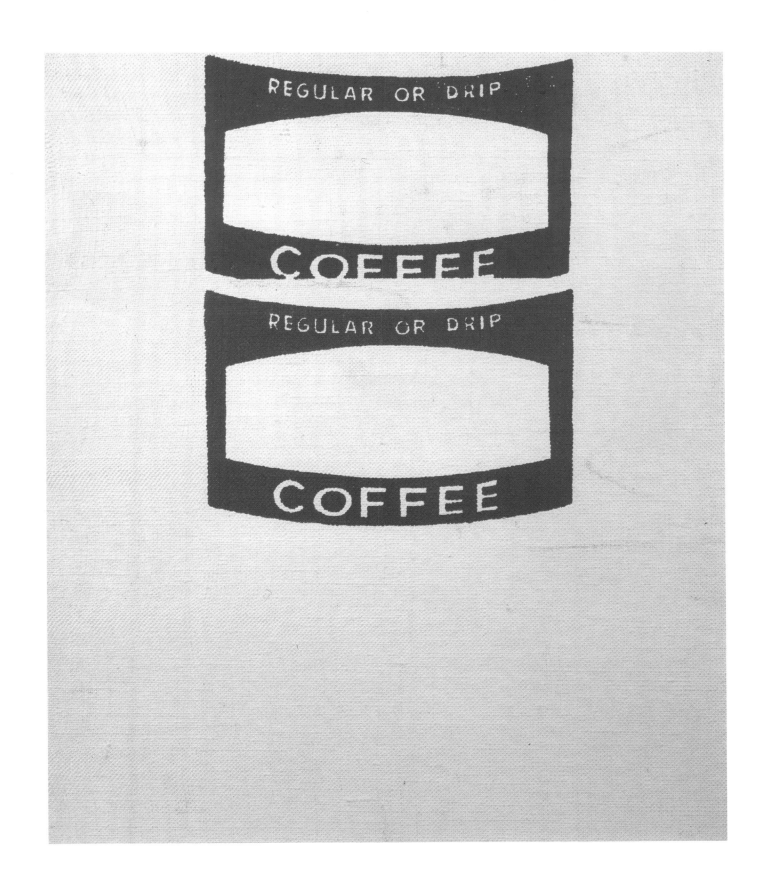

originals that went out over his name. He might provide input on the colouring and lettering; but the graphic work, half print and half original, was really a manufactured product. Reviewing the work process in retrospect, Nathan Gluck (one of Warhol's earliest collaborators) could still speak enthusiastically of the method. As he tells it, when Warhol got more work to do he needed someone to help him. One of

Coffee Label, 1962
Silkscreen on canvas, 29.5 × 24 cm
New York, private collection

"My instinct about painting says, 'If you don't think about it, it's right.' As soon as you have to decide and choose, it's wrong. And the more you decide about, the more wrong it gets." ANDY WARHOL

"What's great about this country is that America started the tradition where the richest consumers buy essentially the same things as the poorest. You can be watching TV and see Coca-Cola, and you can know that the President drinks Coke, Liz Taylor drinks Coke, and just think, you can drink Coke, too." ANDY WARHOL

Gluck's friends had once helped him out for two months and then left him in the lurch. Warhol had asked him if he might . . . Well, Gluck stepped in and worked at his place – which at that time was located at 242 Lexington Avenue – for about three to five hours per day. Andy lived on the top floor with his mother, Sam and Hester (the cats). Whenever Andy had a deadline for the *New York Times* or some fashion magazine, he usually came home loaded down with shoes, jewels, perfume bottles, underwear or fashion stuff of one kind or another to make illustrations of them. It was Gluck's job to draw these objects in precise detail and sometimes to arrange them in a layout. Andy then corrected the details in the drawings or changed the composition of the layout. The drawings were then traced onto a different piece of paper, after which the "blotting" started, resulting in the finished drawing with the characteristic blotted line. Gluck says that from time to time Andy squeezed ideas out of him – for a Christmas card or a layout. And the work was fun. Gluck's description correctly reflects Warhol's working method and his outlook on work. He decided and controlled, selected and sometimes even ratified the ideas of his assistants. Here, on Lexington Avenue, he tried out what he later was to carry out on a larger scale in his legendary "Factory."

Yet neither Warhol's working method nor his techniques were unusual in a successful commercial artist and only the gurus of the idealistic view of art would be shocked by his use of the industrial society's work-sharing system. The artist – challenger and opponent of industry and bureaucracy – who himself supervises the whole process of his work, is an esoteric idea born of an idealistic German spirit which had animated the American arts for a long time, from Albert Bierstadt's monumental landscapes to Jackson Pollock's cosmic eruptions.

In order to pass their painting off as an "original" the Renaissance painters themselves only had to paint the most important parts of a painting, such as the face of the Madonna, while they left the rest of the fresco or picture to their assistants. Peter Paul Rubens perfected the principal of work-sharing and even established his own "factory" with specialists in landscape or the painting of animal carcasses, and some of them went on to gain world fame (Anthony van Dyck, Jacob Jordaens and Frans Snyders). The master designed the first sketch, determined the details of the composition and then got on with his own business, such as negotiating contracts or travelling on a political mission. He usually combined the two without scruple. In those times an artist was a person who was gifted with the special talent to create a world using colours and shapes, which could awaken feelings, kindle passion, and convey an insight more beautiful, more powerful and yet more shocking than the world of our daily lives. Only in later centuries did we see the artist as a melancholy genius who in his splendid isolation literally struggled with his art. The status symbol of owning a painting by a famous painter was a bonus for those who could afford to commission such a painting. Even Andy Warhol was secretly amused by the fact that many people

hung on their walls his pictures of the electric chair or of accidents.

PAGE 28:
Peach Halves, 1962
Oil on canvas, 177.5 × 137 cm
Stuttgart, Staatsgalerie

Warhol was acknowledged as a commercial artist, but he had not yet gained recognition as a "pure" artist. 1956 was to be a year of decisive importance for him. He undertook a world trip which included a visit to Florence in Italy, where he was deeply moved by the great Renaissance works of art, which fired his artistic ambitions. In the same year he won the 35th Annual Art Directors' Club Award (for the shoe advertisements he had produced for the Miller shoe store); the Museum of Modern Art invited him to participate in the "Recent Drawings, USA" exhibition. This was his first step into the world of "serious" art and *Life* published a number of his illustrations. It was at this time, too, that Andy Warhol began to show an ever increasing interest in the world of films and film stars.

Warhol had become a familiar figure in Manhattan's high society. He earned good money, collected Tiffany lamps and glasses, chairs from Vienna, American antiques and even works of art – a Magritte, a few lithographs by Miró and so on, according to Calvin Tomkins. One of his friends at the time called the style in Warhol's apartment 'Victorian-Surrealist'. Until her death his mother lived with him and was as much a part of the life in his modestly decorated two-storey apartment on Lexington Avenue – between 33rd and 34th Street, right above Florence's Pin-up Bar – as were his various Persian cats – all of whom were called Sam if male, or Hester if female. Everybody knew that "he had to be someone special." According to David Bourdon, Warhol was dressed to kill, wore a tight-fitting suit with a bright red Paisley lining. He was not goodlooking but boyishly or rather impishly nice, with high, pale rosy Slavic cheeks, and when he let out a deep, bubbling laugh, he had a tendency to throw his head back. Even in those Pre-Pop days, Andy was something of a celebrity – a much-admired, prize-winning illustrator with a distinct drawing style. He had an extremely dandified air about him, but was also cheerful and self-critical. He seemed to be equally shy and self-assured, reserved when he talked about himself, but nevertheless completely convinced of himself, and did not at all hesitate to put himself in the limelight.

David Bourdon's comment emphasizes the term "Pop." And yet only a critic of today (who might perceive the past as a mere forerunner to the present) can look at the Fifties in terms of the "Pre-Pop Decade." Reality was different – art in the Fifties was ruled by the non-representational. Western culture, with the exception of some French and Italian "dissidents," was distinguished by a missionary zeal to fight for freedom within the arts, for the abstract, seen as the all-pervasive and superior opponent of the musty and philistine "Realism" of socialist and communist stamp. Groups of outsiders in literature, theatre, film and fine art had indeed already declared war on narrow-mindedness, and the ghosts of Dada and Marcel Duchamp again haunted the scene. The Pre-Pop era? No. The established art scene was, rather, hit by Pop like a bolt out of the blue and it reacted accordingly – with fear. Those who did not lose their nerve regarded the sudden Pop storm as a phenomenon that

PAGE 29:
**Close Cover before Striking
(Pepsi Cola), 1962**
Acrylic on canvas, sandpaper,
183 × 137 cm
Cologne, Museum Ludwig

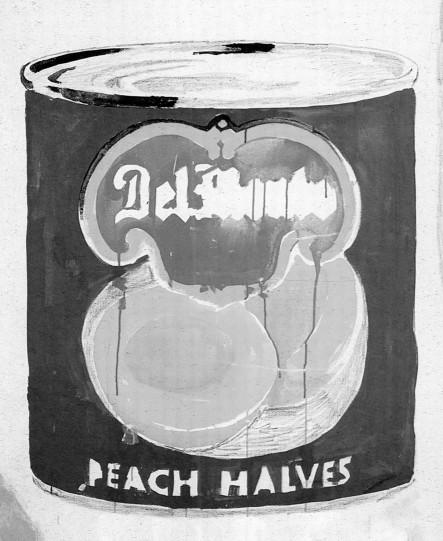

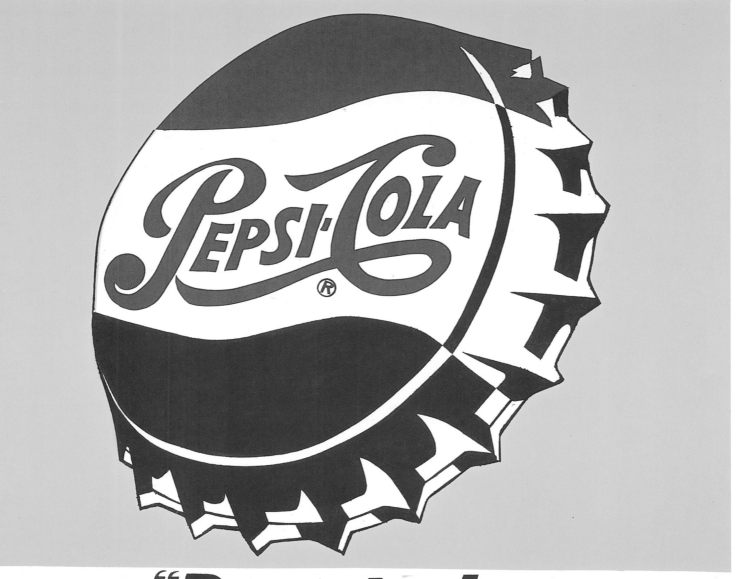

say "Pepsi please"

CLOSE COVER BEFORE STRIKING

AMERICAN MATCH CO., ZANSVILLE, OHIO

would quickly pass. Greenberg, the all-powerful art critic, rated this unwanted phenomenon even lower, merely regarding it as an episode in the history of taste. One had to be extremely open-minded to give even rudimentary credit to Robert Rauschenberg's heavy "paintings" and Jasper Johns' peculiar pictures. Yet, they did not totally betray the sacred convictions of Abstract Expressionism and they still demonstrated a subjective conception and an individual stamp — in spite of the strange integration of everyday things — be it in factual or painted form. Art still had the upper hand over ordinary reality, even if it was troublesome. "Pop" hit the art world like a spring tide and there was only one person, who — albeit unconsciously — was prepared for it: Andy Warhol. To that extent he could be said to represent the era of Pre-Pop.

Many claim to have invented the term "Pop." It was first seen as a picture title for one of British artist Richard Hamilton's lost collages — some assume it stands for "popular." It was English art critic Lawrence Alloway who introduced the term "Pop" into art literature. It was used to describe artistic work which looked analytically at art articles of mass consumption, at trademarks and visual symbols of the consumer goods industry, at the formulaic appeals of advertising, at schematic comic strips, at the stereotype idols of the film and music scene, at the flickering luminous advertising in big city centres — in short, it dealt with the trivial vocabulary of simple symbols and pictures produced for the same rapid consumption as the goods they represented. In Britain Pop Art was condensed to a vision of emptiness, stupidity and betrayal.

Though Andy Warhol worked in the field of commercial art in advertising — he designed adverts for exclusive products and exclusive magazines — this was not to be his ultimate world. In the early Sixties he abruptly and radically changed direction. Suddenly they were there: the drawings and shortly afterwards the pictures, using dollar bills, film stars, soup tins, Coca Cola and ketchup bottles, comic strips with Dick Tracy, Popeye and Superman. He used boards with comic strip motifs for the background of a window display at the big Bonwit Teller store on 57th Street (p. 18).

At Leo Castelli's he bought one of Jasper Johns' drawings for $350 and he met Johns and Robert Rauschenberg through Emile de Antonio. He became friends with Henry Geldzahler, the influential trustee of contemporary art at the Metropolitan Museum, and he began working with Ivan Karp, director of the Castelli Gallery. Warhol also changed his outer appearance, as David Bourdon noticed; as he describes it, Warhol's transformation into a Pop person was thought-out and well-considered. He put his dandified airs behind him when he gradually changed from a worldly-wise person with a subscription to the Metropolitan Opera into a gum-chewing, seemingly naive teeny-bopper who submitted to the lowest forms of Pop culture. When he was waiting to receive important visitors from the art world, major advocates of the new art, such as Ivan Karp or Henry Geldzahler, for example, he took off the classical record and put on a pop album. He had deliberately set up his record player in such a way that

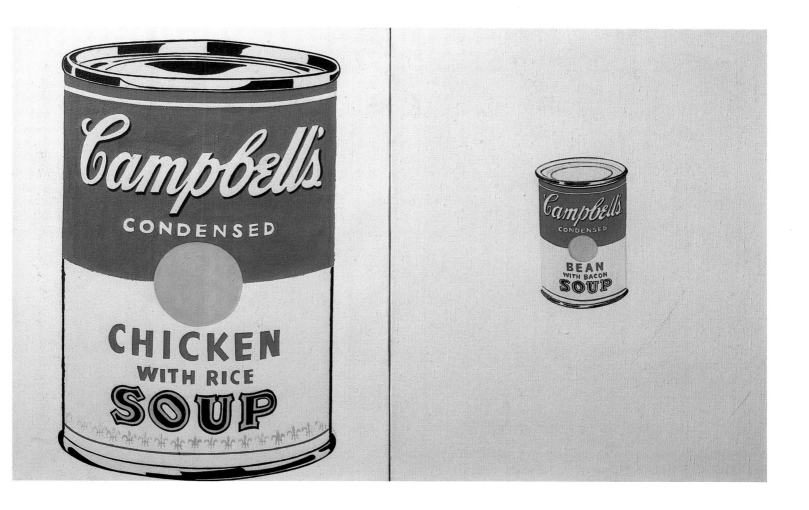

Campbell's Soup, 1962
Oil on canvas (two pictures in one frame),
50.5 × 81 cm
Mönchengladbach, Museum Abteiberg

he played the same pop song over and over again, which provided the anaesthetic background music for the pictures he composed on his canvases.

Warhol's breakthrough as an artist was set in motion when he discovered that he had hitherto chosen the wrong subjects for success in pure art circles. They were suitable for chic designs, but they were too up-market to impress the inverted snobs of the New York art world. Only his drawings of shoes were faintly vulgar. The commercialised art motifs had degenerated into cheap decorations – they lacked power and provocation. From the early Sixties Andy Warhol ceased to enrich commercial art with the forms and formulas of "a higher art form" but – on the contrary – branded "pure" art with the visually harsh images of mass advertising. He turned his back on the elegant stores of Fifth Avenue and turned his attention to the supermarkets of Queens, the Bronx, Brooklyn and the American suburbs. He chose his subjects from lowlier domains. By so doing, he catapulted himself into the sphere of art for art's sake and within a few months he was acknowledged as a "true" artist. Comics, bottle and tin labels, mass-produced photographs (and later photographs he had taken with his polaroid) were to become the basis of his artistic creations.

While at first he still worked with brushes and paint (cf. pp. 24, 28) he perfected his printing techniques at the same time (cf. p. 23). Nathan Gluck, one of his assistants, described the work process

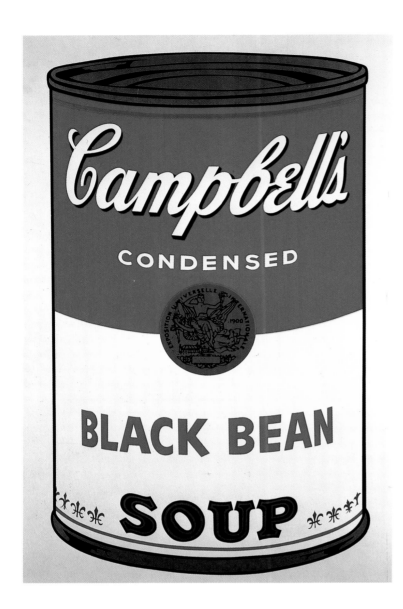 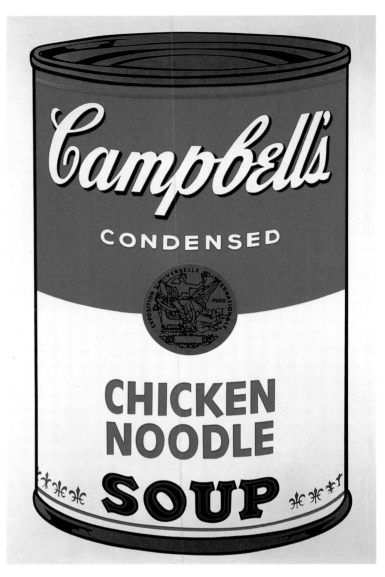

PAGES 32 and 33:
Campbell's Soup I, 1968
4 sheets from portfolio of
10 silkscreen prints
Size: 80.5 × 46.7 cm; 89 × 58.5 cm
250 copy edition, numbered with a stamp
and signed on the back in ball point
Publisher: Factory Additions
Reproduced by kind permission of
Neue Galerie – Ludwig Collection, Aachen

thus: he claims that even before his intensive involvement in Pop painting, Andy had wanted to make prints. First they carved flat blocks of balsa wood (he seems to recall that this was how they made a two-tone Coke bottle). Then they discovered that it was easier and faster to work with soapstone. They were able to get hold of a few large-sized blocks of this golden brown 'soapy' material and set about carving birds, flowers, hearts, suns that peek through the clouds and other things in it. These were used in turn as dies, so to speak, working with Indian ink. Then the surfaces could be coloured in. Andy printed a few motifs on 45–60 cm pieces of wrapping paper. Bouquets, still lifes and other arrangements were printed and coloured in. If something had to be oversized, either parts of it were printed in blotted line or it was line-drawn and the dots were added in later.

Warhol even changed his style: the swinging lines of his commercial graphics were replaced by heavy, broad, coloured lines and his objects acquired those deep shadows known to ambitious amateur photographers. "Warhol is looking for everyday, common

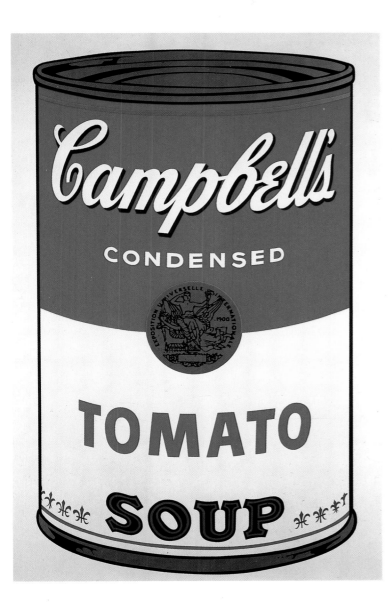
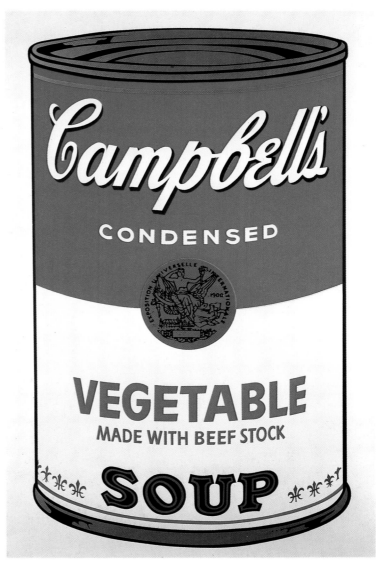

subjects and for a painting technique (in the early pictures of this period he still painted by hand) which renounces everything that had determined his drawings. For his soup tins and Coke bottles he chose a painting technique which was foreign to him. It was not a case of a continuation of opulent themes and efficient placard painting so much as a radical break." (Werner Spies). Earlier he had dressed his luxury articles with that glamour achieved only by the expensively special and now he turned to the mass market articles (cf. pp. 20, 25, 28, 29, 31–39) of the American consumer. There is no doubt about the fact that these paintings are a much more emphatic and recognisable symbol of the American Way of Life than his shoes of the rich and famous.

In 1962 he did the paintings which almost entirely define his personal artistic repertoire. Campbell's soup cans (p. 21), Heinz Tomato Ketchup bottles, dollar bills and wads (p. 22), Coke bottle tops and the portraits of famous film stars, such as Joan Crawford, Ginger Rogers and Hedy Lamarr. The contours of the objects portrayed are drawn in a heavy bat flowing; the lettering on labels, or

"Working for a lot of money can throw your self-image off. When I used to do shoe drawings for the magazines I would get a certain amount for each shoe, so then I would count up my shoes to figure out how much I was going to get. I lived by the number of shoe drawings–when I counted them I knew how much money I had."

ANDY WARHOL

33

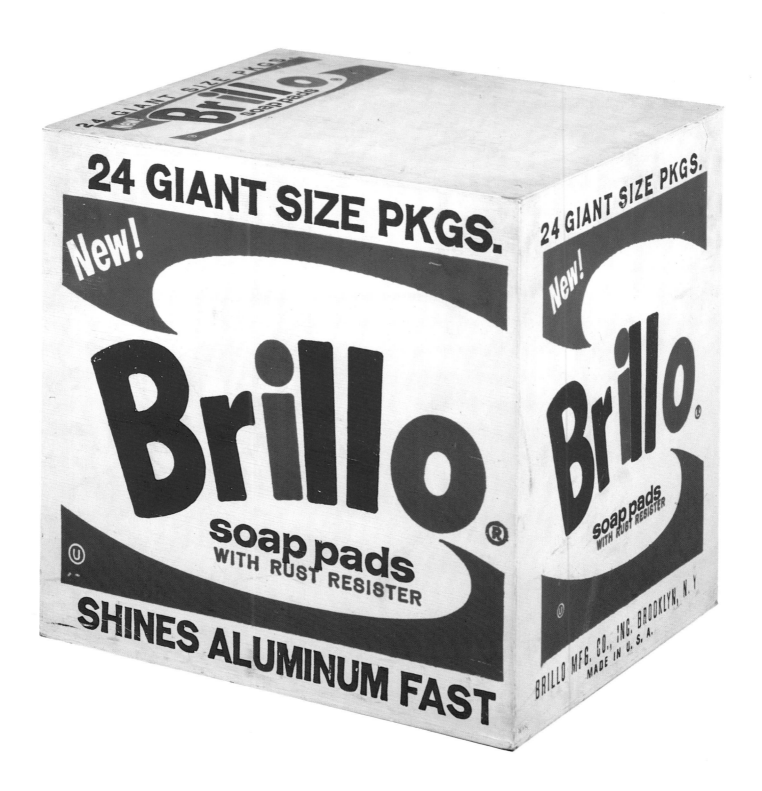

Brillo Box, 1964
Silkscreen on wood, 44 × 43 × 35.5 cm
Brussels, private collection

other printing, are clearly worked out, the backgrounds are frequently hatched and contrasts accentuated in a stark black and white. "In contradiction to his work of the Fifties one notices a consciously anti-aesthetic touch in his paintings. This becomes even more obvious if the drawings, which were drawn with a strong pencil, are partially coloured with watercolour. The delicate and elegant lines of the 'blotted-line' drawings of his earlier phase are gone . . . Warhol obviously neither wanted to continue the tradition of the elegant and decorative line, though his artistic talent had predestined him for this technique, nor did he stylistically want to pass through a uniform tradition in a conventional academic sense." (Rainer Crone)

34

Warhol fundamentally changed the face of art, but where did he get his inspiration? In the first place, there were the paintings of the "Ash Can School". This term describes a group of eight painters who had followed Robert Henri and John Sloan and as Realists had found their way into the American history of art. They laid the foundation for a trend of current, socially committed and visually arresting painting, which neither favoured nor discriminated against an issue. Robert Henri decreed that it was irrelevant whether the subject of a work is beautiful or ugly; rather, the beauty of a work of art lies in the artwork itself. These paintings depict situations and events in the life of a big city. It is likely that inspiration for Warhol's work came even more from two American painters of the Twenties and Thirties, Charles Sheeler and in particular Stuart Davis, whose paintings anticipate the world of Warhol. In the late 1920s Stuart Davis, one of Robert Henri's disciples, created the artistic programme of "Stan-

Brillo Box, 1964
Silkscreen on wood, 33 × 41 × 30 cm
Brussels, private collection

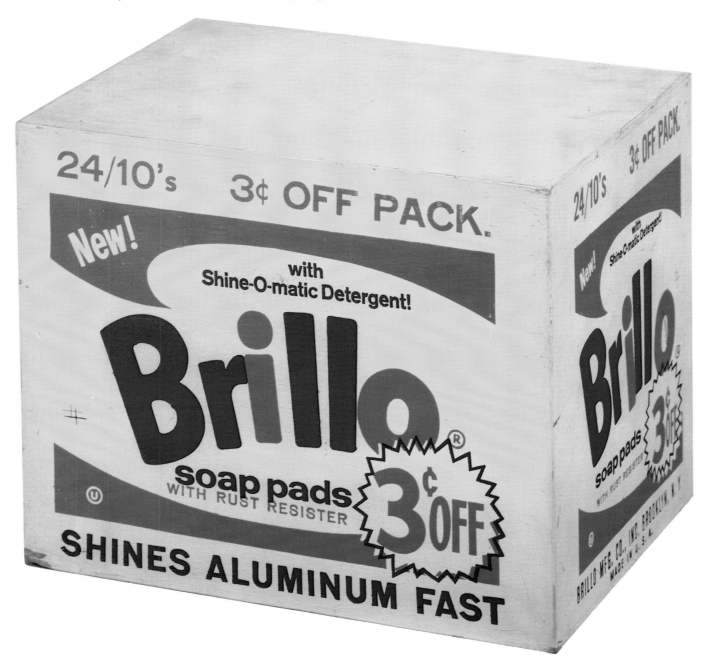

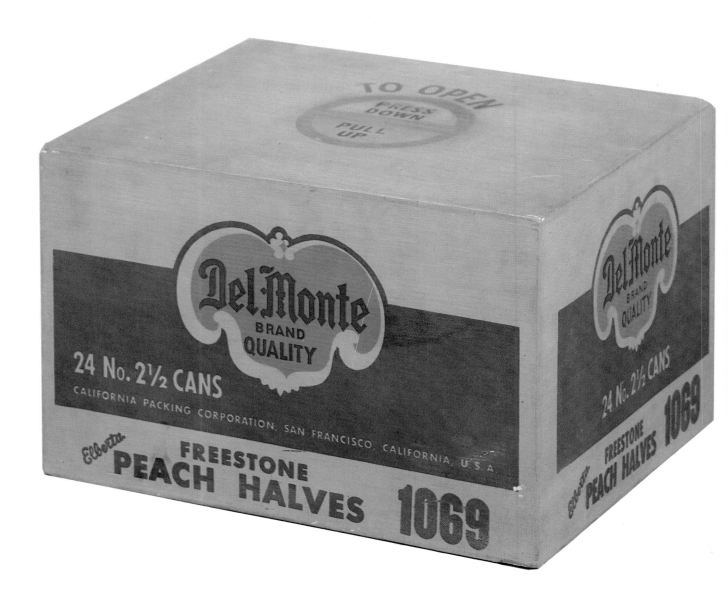

Del Monte Box, 1964
Silkscreen on wood, 24 × 41 × 30 cm
Brussels, private collection

dard Still Life" and his paintings of a rubber glove, an electric fan and other items began the terminology of Pop Art. In understanding Andy Warhol's work one must also take into consideration Charles Sheeler's photographic paintings, which certainly had more influence on Warhol's art than Ben Shan's work, attacked by him before he moved on to Pop Art.

Warhol's 1960 painting *Storm Door* (p. 24) is conventional, relatively undecided by comparison with later works and relies on the tension created by the juxtaposition of light and dark. It is painted with a brush in the carefully careless manner of Abstract Expressionism. The canvas is divided into three parts: the upper part is characterized by a dark box-like, closed area, partially interrupted and permitting a glimpse of a lighter background; the lower section (approximately the same size as the upper) is defined by a coat of white paint. The central section of the picture acts as a link between the upper and lower sections, showing traces of brush strokes as well as paint drips. The picture contains several numbers, the beginning of a sentence in printed letters and the outline of an opened door in the middle section of the painting. The numbers and letters are solid, but the inner part of the door is painted in such a way that it

appears to mirror a section of architectonic space on the left-hand side of the painting. The figure "12" and the beginning of the sentence "MADE TO" – unexpectedly breaking off – are the only parts that look as if they might have been stencilled: the door might have been taken from a comic. And yet this painting is still too influenced by the spirit of Abstract Expressionism to be seen as a turning point.

Robert Rauschenberg and Jasper Johns had made an earlier attack on the bastions of Abstract Expressionism, Robert Rauschenberg with his powerful assemblages – breathtaking summaries, carried out by vehement swings of the brush akin to action painting and using rusty or worn-out real objects, Jasper Johns with his paintings whose widespread visual signals and emblems were painted with a sensitive and cultured hand. Both artists were instrumental in launching the change without themselves making the break. It is therefore understandable that they were not impressed by a painting like *Storm Doors*. It was no secret to Andy Warhol that he was still more or less ignored by the progressive New York art scene, moving forward under the leadership of Robert Rauschenberg and Jasper Johns. But he did not like it. Emile de Antonio was such good friends with Jaspar Johns and Robert Rauschenberg that Warhol thought he could probably explain something to him that he had always wanted

Heinz Tomato Ketchup Box, 1964
Silkscreen on wood, 21 × 40 × 26 cm
Brussels, private collection

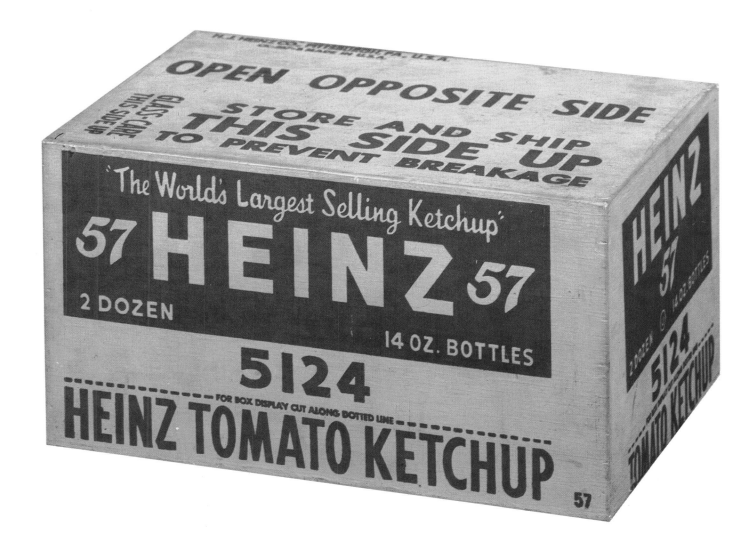

Various American product cartons, 1964

to know. And Emile obliged him, in no uncertain terms: Andy was too effeminate for them and that confused them.

There were two reasons why the newcomer was not liked by the protagonists of the latest American art trend: his attire and his acquired mannerisms were like a parody of their virile homosexuality. They saw themselves as posing a vigorous challenge to the softness of Abstract Expressionism – only to be deflated by Warhol. On top of this Andy Warhol had not yet managed to rid himself of the stigma of the commercial artist and his desperate efforts to put himself on a par with "serious" artists by copying their ideas seemed to reveal his lack of comprehension. His painting *Storm Doors* was a striking proof that he was on the wrong path. Rauschenberg and Johns were far more advanced in their trips into unknown territory – especially Johns, who with his flags and targets encapsulated the problem of the original and the image. As a symbol the flag in his painting *Stars and Stripes* stands for the United States of America, as an art object it merely represents a cool demonstration of artistic autonomy. It is only the visible craft which went into painting it which gives it artistic individuality and which marks its difference to, for example, the ready-mades of Marcel Duchamp.

Warhol's experiments demonstrate the circumspection which characterised his approach to his work. Simultaneously, he painted pictures in different styles, with different subjects and in different techniques. While creating *Storm Doors* he used comic models for the first time – if one believes the date of the paintings. Popular figures, such as Popeye and Dick Tracy, are found in his pictures. Using a projector he literally projected them onto a canvas and roughly traced them. As in *Storm Doors* he combined letters and objects to form a subject. At first glance his paintings give the impression of having been produced with a stencil, but Warhol did indeed use a brush. Even though the painter restricted himself to a few unmixed colours and laid them on emphatically, the traces of his craft are evident. However, as Gail Kirkpatrick has noted, instead of lending the work a personal touch, dripping swabs of paint, for example, only serve to underscore the already lifeless quality of what is pictured. The drops of paint tend to convey the impression of sloppy workmanship rather than a sense of vitality and expressiveness. Warhol had already turned his back on the principle of Abstract Expressionism and with the dispassionate eye of an observer had turned his attention to a kind of realism which was beginning to establish itself as an art form in its own right – without expressly claiming autonomy. His first real Pop paintings had of course functioned as window dressing at Bonwit Teller (cf. p. 18) – but the stigma of commercialism neutralised any explosive effect they might have otherwise had on the art scene.

Andy Warhol was not the only artist searching for new approaches in New York at the beginning of the Sixties. The city was experiencing a new cultural awakening mobilised by President John F. Kennedy's proclamation of a "New Frontier". For instance, Roy Lichtenstein (almost at the same time) also recognised the fresh

OPPOSITE:
Brillo, Del Monte and Heinz Cartons, 1964
Silkscreen on wood, 44 × 43 × 35.5 cm;
33 × 41 × 30 cm; 24 × 41 × 30 cm;
21 × 40 × 26 cm
Brussels, private collection

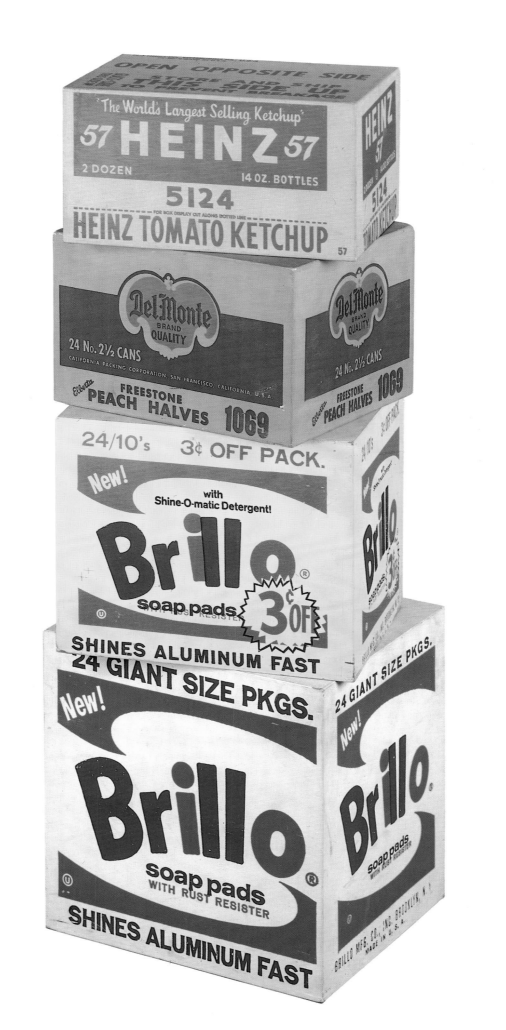

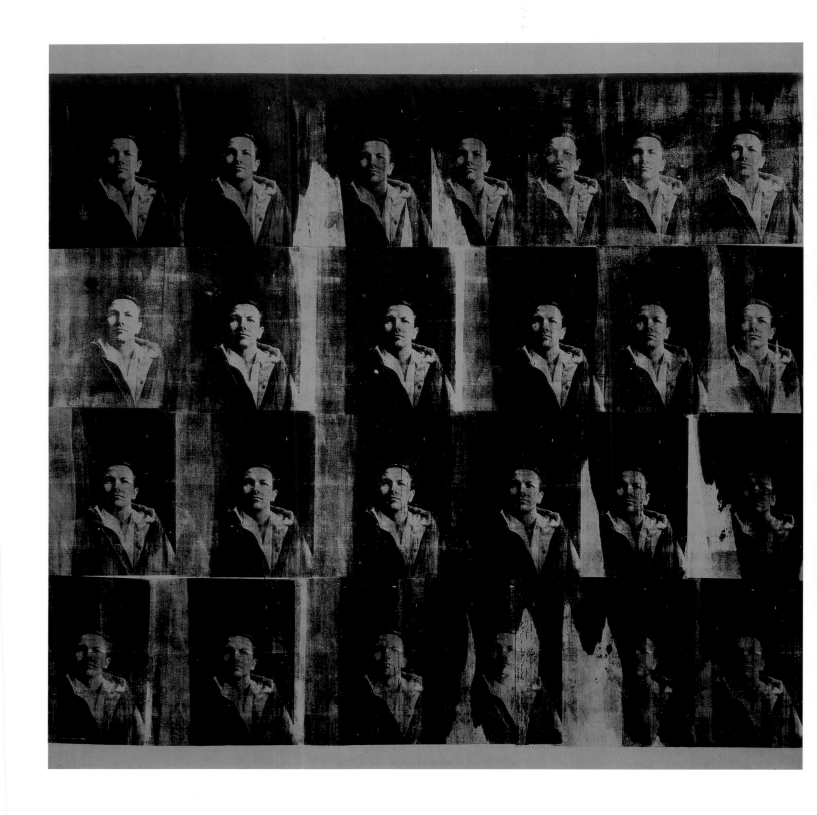

Texan, Portrait of Robert Rauschenberg,
1963
Silkscreen on canvas, 208 × 208 cm
Cologne, Museum Ludwig

imagery of popular comics. Below the cultural line drawn by the social elite, the development of a specific, direct and emphatic image culture was taking place. It was not the political news and comment in the daily papers that readers devoured avidly but the comic strip pages. The most popular figures became models for the heroes of Hollywood films, and the power and visual wit of these stories were often superior to those of the cinema. When he was ill as a boy, Warhol had himself taken comfort from comics. They were as much a self-evident part of an American adolescent's everyday life as televi-

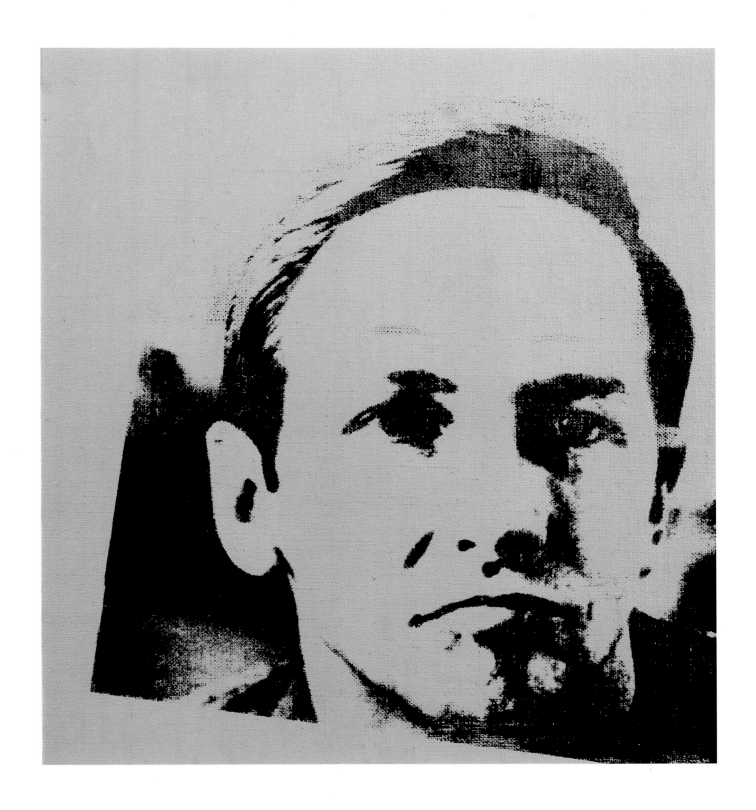

sion was soon to become. No matter which stories they tell, comics never lose touch with the world of experience, while using specific means of conveying reality: "The illusion of reality is achieved by using procedures familiar to draughtsmen since the Renaissance: spatial perspective, anatomical precision, and the mimetic use of dynamics. The form owes something to the methods of film, with overviews, close-ups and cuts. This too is done in the interests of verisimilitude; films and photographs, after all, are still widely considered to be true to reality." (Jürgen Trabant). Films and photos func-

Robert Rauschenberg, 1967
Silkscreen on canvas, 30 × 28 cm
Salzburg, Thaddaeus Ropac Gallery

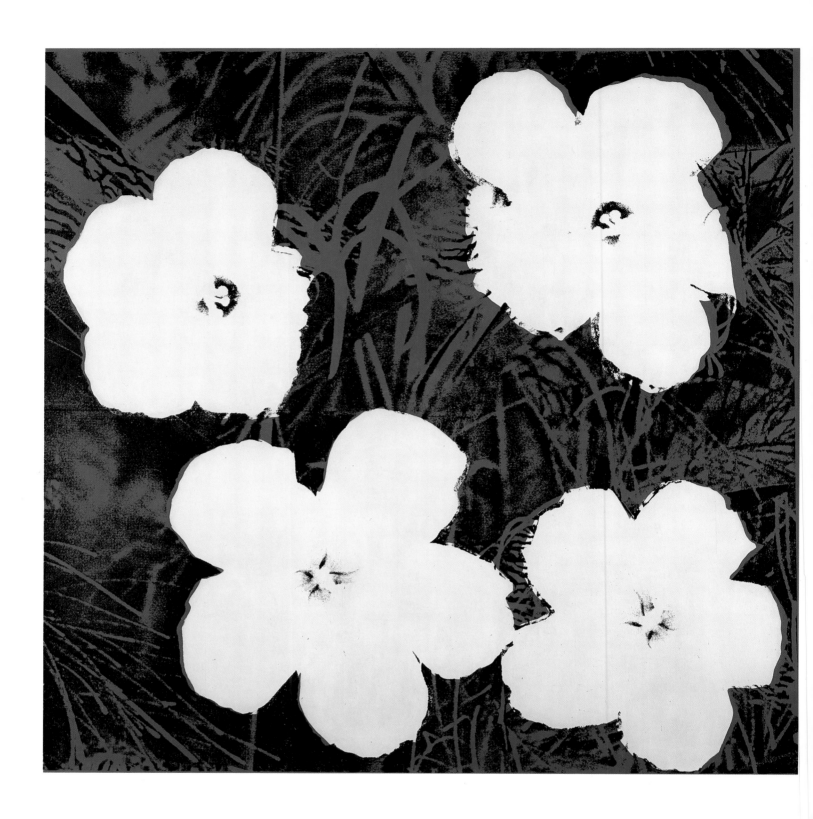

Flowers, 1964
Synthetic polymer, silkscreen
on canvas, 208 × 208 cm
Reproduced by kind permission of
Thomas Ammann, Zurich

tion as mediators between empirical reality and the pattern-like representation of comics and thus enhance their realistic character. By taking objects for his paintings from sections of popular comics, Andy Warhol came closest to acquiring a central artistic theme (if he ever actually had one). But when he realised that he had a competitor in the innovative use of trivial iconography he abruptly ended his experiments (although they were aimed in a completely different direction to Lichtenstein's aesthetic paintings). Warhol laconically remarked than when he told Henry Geldzahler he was going to stop

painting comic strips, Henry told him not to do that. Ivan Karp had just shown Lichtenstein's Ben Day dots to Andy, who said to himself, "Now, why didn't I think of that?" He decided on the spot to stop painting comics because Lichtenstein did it so well and decided instead to work in a different direction where he, Andy Warhol, would be the first. With quantity and repetition, for example. Geldzahler told him his comics were fantastic – no better or worse than Lichtenstein's – that the world could use both of them, and that they were not at all alike. Geldzahler later conceded, however, that Warhol had, of course, been right, logistically and strategically speaking: the territory had already been occupied. In an epoch where originality alone counted, in art and in life generally, he who came second was neither favoured with special attention nor with adequate esteem. In the meantime the pressures of marketing were increasingly encroaching on art, and those artists who did not have an unmistakable style were considered to be lacking. Even in the art world a trademark is a guarantee of quality – at least it seems like it.

Portrait of Leo Castelli, 1973
Acrylic and silkscreen on canvas,
110 × 110 cm each
New York, Leo Castelli Gallery

FINAL ★★ 5¢ **New York Mirror**

WEATHER: Fair with little change in temperature.

Vol. 37, No 296

MONDAY, JUNE 4, 1962

C

129 DIE

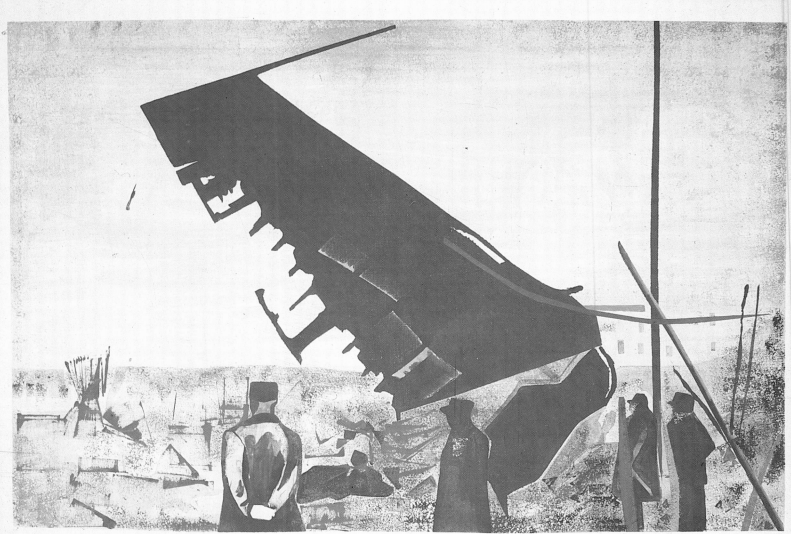

(UPI RADIOTELEphoto)

IN JET!

A Technique Becomes a Trademark
Silkscreen Printing as an Art Form

A painting with a morbid subject marks the beginning of a remarkable output of Warhol pictures launching a new era in the history of art. It was the catastrophe of an airplane crash in New York that sparked his artistic flame. Yet it was less the crash of the passenger jet itself that triggered Warhol's artistic initiative than the photo of the wreck published in the *New York Mirror* on June 4, 1962. Warhol projected the press photo showing the complete scene with the still erect tail unit of the crashed jet onto a canvas and made a painted copy (p. 44). Not only did he use the photographic image but also the tabloid's headline, spectacularly large capital letters beginning with "129 DIE" and continuing (below the photo) with the addition "IN JET." The name of the newspaper runs along the upper edge of the painting, including the date of issue and the number of the edition. Warhol left out a few irrelevant details and added a star at the upper left. The photograph, newspaper's name and letters are painted with arcylic paint on canvas.

Looking back it seems surprising that Warhol took so long to find the theme which was to prove the catalyst for his emergence as a true artist: the world of photography – a world more radically determining the outward appearance of experienced reality than comics or the trademarks of consumer articles or works of art themselves. Photography is a more authentic reflection of what we see with our own eyes than any pictorial image that has gone before, almost immortalizing visible reality. Warhol as a dispassionate observer must have noticed early on the outstanding role that photography and film played in people's perceptions of reality. But it is likely that photography in the Fifties was even more despised in art circles than the imagery of comics and advertising. Rauschenberg had "mounted" photos within his paintings, certainly – but as a mere "quotation" within their artistic context. Strictly speaking, photography ranked low in art circles, but precisely because of this it was an ideal vehicle for Warhol's purposes. The German painter Gerhard Richter felt similarly. It was Warhol and Richter who introduced photography into art and who granted it artistic legitimacy. They did not secretly copy photographs – as Renoir, Ingres, Delacroix and other artists of the 19th century had done – but used them openly and as component parts of that reality; the photograph filters reality,

"If you want to know all about Andy Warhol, just look at the surface of my paintings and films and me, there I am. There's nothing behind it."
ANDY WARHOL

OPPOSITE:
129 DIE IN JET (Plane Crash), 1962
Acrylic on canvas, 254.5 × 182.5 cm
Cologne, Museum Ludwig

News photo, subject of "Red Race Riot"

changing the material penetrating through its grid by imprinting on it its own pattern of perception. In the painting *129 DIE* Warhol neither portrays reality directly nor spontaneously, but makes use of a vehicle that acted as an intermediary between reality and the viewer – using a press photo of a disaster that had actually happened. Realism in this painting is not true realism, it is not even one of its aspects; it is the realism achieved by a form of illustration which is of itself proven real. Because of its exceptional authenticity the photo counts as an inviolable testimony to the reality which it depicts. Less dependable truth was also being spread by the flood of seemingly authentic depictions of the mass media: magazines, oversize advertising, and film and television, slowly triumphing over empirical reality. In Tom Wolfe's *Bonfire of the Vanities,* for instance, the truth about the hero – Abe Weiss, Senior Public Prosecutor for the Bronx – is solely determined by what is shown on television.

In his painting *129 DIE* Warhol illustrates the vulnerability to media treatment of real happenings in the age of mass media. The fact that 129 people died a violent death in an airplane crash is here presented as an aesthetic arrangement of pictorial, photographic image and effective capital letters. The picture, however, is only partly influenced by the artist: the death of 129 people had already been turned into an object of aesthetic quality by the photograph itself (which appeared like a bad omen on the front page of the *New York Mirror*), and by the rhythmic composition of the headline. Thus, the artistic truths of this picture are as much occasioned by the effect produced by the newspaper's original photograph (and recognised as such by Warhol) as they are by Andy Warhol's intervention as the artist. The true reality – the horror of the crash and its terrible consequences – becomes only a secondary truth of secondary importance to the painting itself. By isolating and enlarging certain elements of the mass media, Warhol sharpens the viewer's perception of the second-hand nature of any experience of reality. Reality multiplied a hundredfold and presented in precise form loses its terror and hence can be consumed by the masses. Andy Warhol's own views on this gradual loss of realism by the substitution of surrogates remain ambivalent. He is a distant, reserved and silent observer of the world.

It is not surprising that literature about Andy Warhol glosses over the theme of *129 DIE,* whilst focussing on the fact that he uses a press photograph. Janis Hendrickson talks about the background, noting that most of the victims of the catastrophe were members of an artist's union from Atlanta, Georgia, returning from an art trip to Europe. As she put it, Warhol must have been fascinated by the fact that these culture-seekers were the victims of their own cultural inferiority complex, whereas in his own pictures he offered original American objects for contemplation. Front pages of tabloids had previously inspired some Warhol drawings and paintings: e.g. the *New York Post,* with its headline "A Boy for Meg" (1961), *Movie Play* with a portrait of Ginger Rogers and the *Daily News* carrying the story of Eddie Fisher's nervous breakdown (a lover's grief over the escapades of his spouse, Elizabeth Taylor) (pp. 48–49). But those

OPPOSITE:
Red Race Riot, 1963
Acrylic and silkscreen on canvas,
350 × 210 cm
Cologne, Museum Ludwig

PAGES 48/49:
Daily News, 1962
Acrylic and liquitex on canvas,
183.5 × 254 cm
Frankfurt am Main, Modern Art Museum

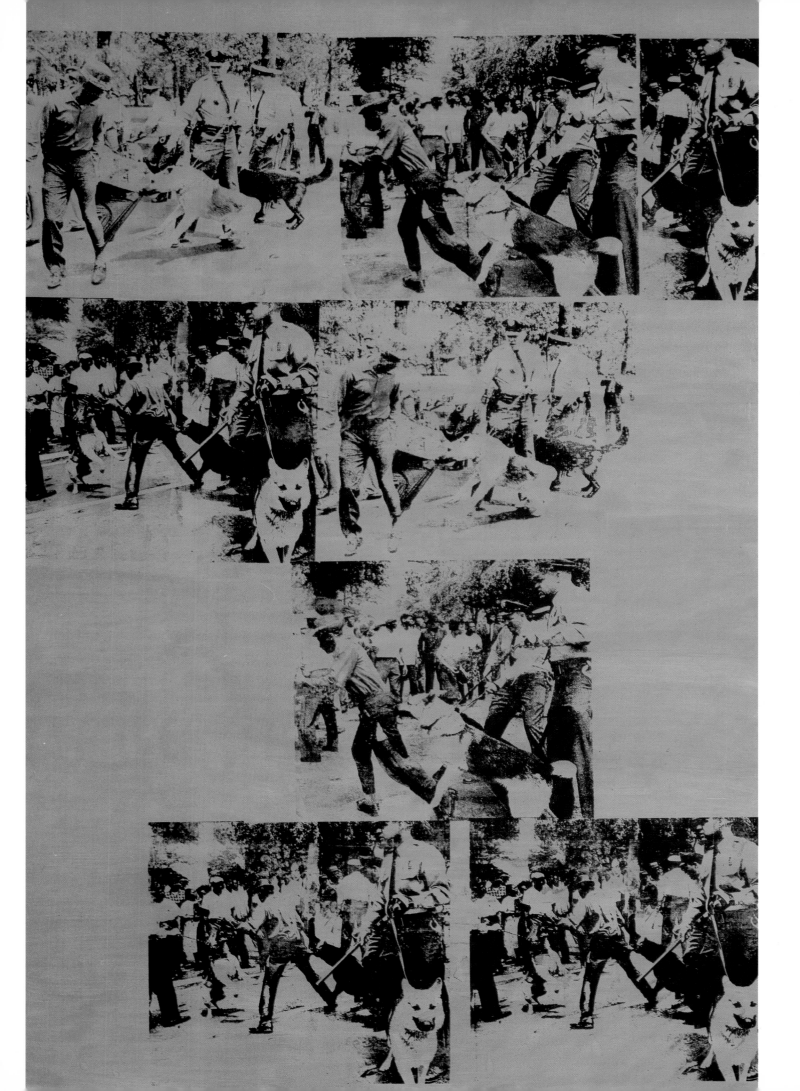

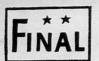

FINAL

DAILY NEWS

NEW YORK'S PICTURE NEWSPAPER ®

Daily—1,900,00
Sunday 3,200,00

88 New York 17, N.Y., Thursday, March 29, 1962 5 CENTS

MET RALLY EDGES LA, 4-3
YANKS CURB CARDS, 4-1

Stories on Page

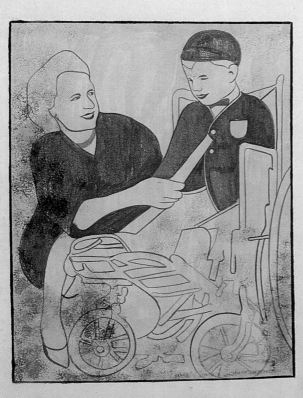

★★ FINAL

DAILY NEWS
NEW YORK'S PICTURE NEWSPAPER ®

5¢

1.43. No.238 Copr. 1962 News Syndicate Co Inc. New York 17, N.Y., Thursday, March 29, 1962* WEATHER: Mostly fair and mild

EDDIE FISHER BREAKS DOWN
n Hospital Here; Liz in Rome

paintings come nowhere near the significance of *129 DIE IN JET,* as in aims and context they belong to the era of luxury and high fashion from which Andy Warhol had now turned away.

To underline this picture's status and importance in the gamut of Warhol's work, Werner Spies subtly interprets it to show how it represents Warhol's final artistic break with Abstract Expressionism. The erect tail unit reminds him of the characteristic black shapes in Franz Kline's paintings: "The erect tail unit, broken off, splintered and bent by the crash, is reminiscent of certain paintings by Mother-well and reminds one of Franz Kline's black paintings, in which such areas also break the plane of the canvas. It seems plausible that with this painting *129 DIE* Warhol symbolized the end of the hegemony of Abstract Expressionism. The fact that Franz Kline died on May 13, 1962 (not long before Warhol painted this picture on June 4, 1962), suggests that the picture was deliberately painted to affirm this." A tempting speculation and not without attraction.

The fact that this painting was to become a catalyst for one of the numerous legends about Andy Warhol increases its importance. Again it was Henry Geldzahler who played an important role here: Warhol was constantly stimulated by other people's ideas without giving up freedom of choice. It is likely that he would have come to use printed photos as the basis for paintings without Geldzahler's advices. It speaks well for his artistic integrity that he tested possible subjects before he used them in his paintings. He collected suggestions just as he collected magazines and newspapers – in order to use them in the fullness of time. But when Warhol realised that a mass-produced picture or a product of day-to-day life could be construed as containing those elements which would allow him to turn it into a mirror of the collective consciousness, he reacted decisively – for not every picture or product typifies the spirit of its age and thus allows it to become an object of artistic value.

This also goes for trademarks and the packaging of the food industry. Soups and vegetables in tins, sauces and drinks in bottles tell us more about our habits than any other cultural testimony. It is also revealing that the products Warhol uses are identified by certain brand names only. Soups by Campbell, soft drinks by Pepsi or Coca Cola, soap pads by Brillo and ketchup by Heinz manifest a way of life and a standard of living. These insignia will reveal to the archaeologist of the future the daily lives of people at the end of the 20th century, they will reveal the standard of production and preservation of consumer goods as well as our collective eating and drinking habits and will influence conclusions drawn about human behaviour as a whole. The use of "product placement" is traditional in American novels to underline the realism of the fiction. When Warhol chose Campbell soup tins, Coca Cola and Heinz bottles, or Brillo cartons for his subjects, he raised them to the status of icons of contemporary culture (cf. pp. 20, 29, 31–39).

In this context it seems strange that few analysts of his work use the term "icon" in referring to Warhol's drawings and paintings but use it in relation to the subjects that they represent. Completely misunderstanding the meaning and character of an icon, critics have

White Car Crash 19 Times, 1963
Synthetic polymer, silkscreen on canvas,
368 × 211.5 cm
Reproduced by kind permission of
Thomas Ammann, Zurich

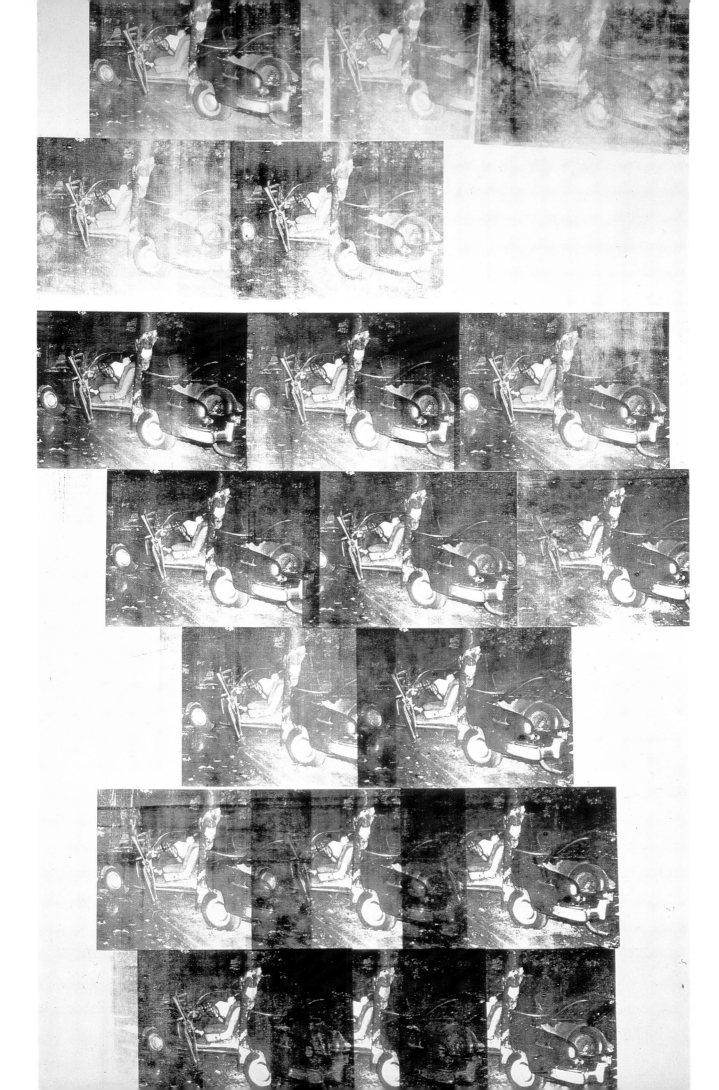

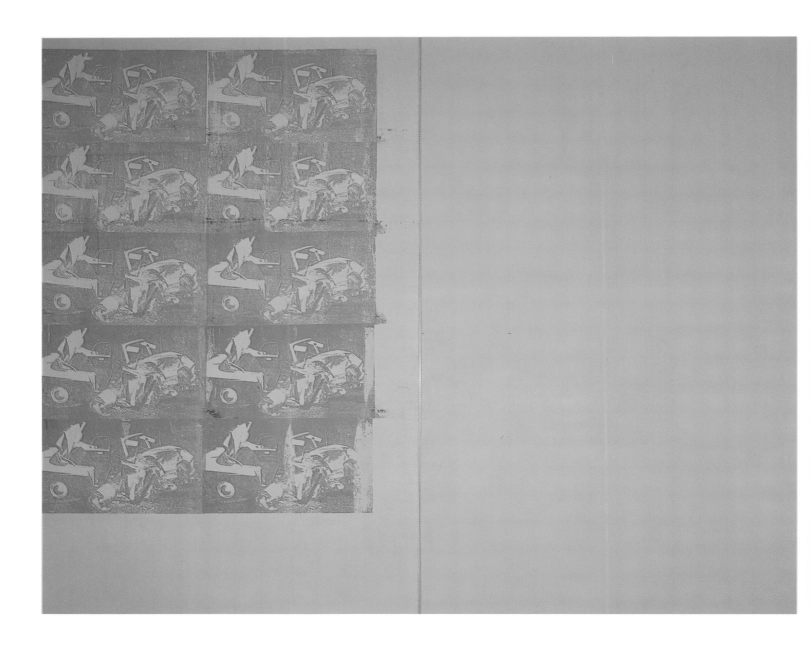

Orange Car Crash 10 Times, 1963
Acrylic and liquitex on canvas,
2 plates, each 334 × 206 cm
Vienna, Modern Art Museum,
Ludwig Collection

asserted tradenames of pertinent consumer articles to be "icons of the age of mass civilization." Icons, whether secular or the original Christian votive tablets (connected with the rites of the Orthodox Church), were produced in large numbers and to a pattern, as they were intended to be alike. But their stereotype form is fundamentally different from the fabricated clichés of industrial mass production. These absolutely identical labels and trademarks only became secularized icons by virtue of an aesthetic act, by virtue of an artist's decision to ennoble them to the ranks of a work of art. This happened because Andy Warhol put them on canvas, artistically "exalting" them and transferring them from supermarket to art gallery. The artist did not transplant actual objects, as Marcel Duchamp once did, from the everyday world (where they did a specific job) into an aesthetic space, making the object itself empirically recognisable but detached from any function; rather he submitted the "ready-mades" of industrial mass production to an aesthetic process of change. The extensiveness and depth of this process is unimportant. For even the slightest intervention of this kind changes the quality of an object.

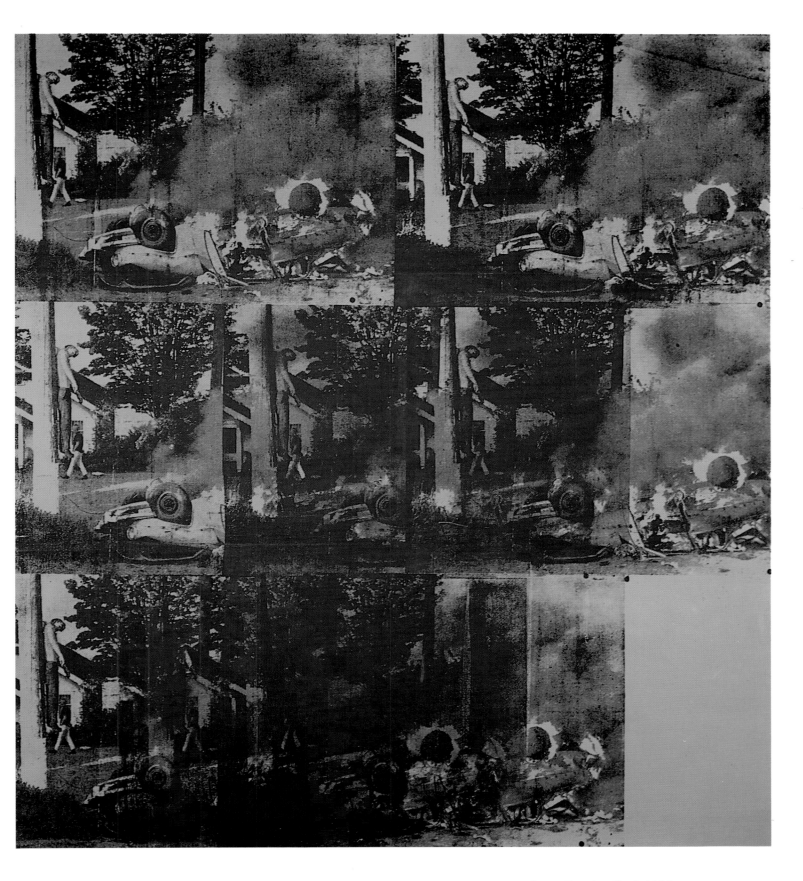

Such an alteration is most fundamental when the object is repro-
duced by the medium of painting — no matter whether it is a three-
dimensional object such as a Coca Cola bottle or a two-dimensional
object, like a dollar bill (pp. 22, 23) or the printed advertisements for
Coca Cola, Heinz Ketchup and Campbell's soups.

Warhol, the buffoon of contemporary art, disliked people looking

Green Burning Car I, 1963
Acrylic and liquitex, silkscreen
on canvas, 203 × 229 cm
Zurich, private collection

Do-It-Yourself (Narcissus), 1962
Pencil and crayon on paper,
60 × 45 cm
Basle, Kunstmuseum

closely at his methods. He played his part in contributing to the general confusion when he slowly switched from the traditional artist's technique of painting to a technique that better corresponded to his new subjects. Warhol, the successful graphic designer, must have been very familiar with this new technique. Having been so closely involved with printed pictures and labels, used as his subjects, he may have also been influenced by their production techniques to look at a different medium. In any case Warhol soon turned to the photographic silkscreen process and applied this medium's potential to his "paintings." The process offered several advantages. It allowed Warhol to get rid of any handmade elements in his pictures, entirely to remove any subjectivity and thus finally to free himself from the clutch of Abstract Expressionism. Furthermore this technique, which produced a painting with mechanical anonymity and precision – once someone had determined its content and colour – corresponded to his own cool, observant and analytical character. It is also likely that the photo silkscreen process itself (lending itself as it does to the formation of a sculptural stereotype) would have influenced Warhol's decision to change media, since this kind of stereotype, as David Borower put it, is not made up merely of the world of facts, but rather of the "inner world" of self-awareness, values and views, and thus diffuses a reflection of the collective soul. His ambivalent attitude toward the aspects of empirical reality accompanies a technique which encourages personal disinterest, probable objectivity, and personal indifference. Warhol's stated reasons are more pragmatic: he said he attempted to paint (the dollar bills) by hand but found it easier to use the silkscreen. In that way, he did not have to manipulate his objects at all. One of his assistants, anyone actually, could reproduce the design as well as he could. "I tried doing them by hand, but I find it easier to use a screen. This way I don't have to work on my objects at all. One of my assistants, or anyone else for that matter, can reproduce the design as well as I could." This technique, new to the world of pure art, did away with complicated and labour-intensive sketches, and by instantly transposing an image onto a screen by photochemical means Warhol attained the immediacy of effect upon the viewer which is peculiar to the photos of the mass media, but without running the risk that his pictures would be as quickly forgotten as those of the gutter press. He prevented this by a special application of the silkscreen process.

Do-It-Yourself (Flowers) (p. 57) epitomizes that point in the artist's development where he changes technique. It shows an only partly finished sketch – in a large format – which can be finished by the part-time painter to convert it into a proper picture, using the painting-by-numbers technique. The composition of the sketch to be painted is schematic, the required colours corresponding to the standardized colours of an industrial culture. The pattern suggests a high degree of craftsmanship and yet is only one example among thousands of identical ones. Were all aspiring painters to follow the instructions in minute detail, the results of their work could not be distinguished from one another by merely looking with the naked

"The idea of America is so wonderful because the more equal something is, the more American it is." ANDY WARHOL

54

eye. Thousands of almost identical originals! This absurd idea in the age of industrial mass production did not merely artistically challenge Warhol, but was also the basis of a new form of artistic practice. He simply reversed the bizarre principle of a painting pattern for dilettantes. With the help of mass production techniques he created a series of paintings which, specifically as a result of the use of this method, can be distinguished from one another (if only by differing tones) and thus do not merely call into question the uniqueness of the 'original' artwork, but even profit by the use of repetition of the original. Thus *Do-It-Yourself (Flowers)* is as unique a painting as any other, for no second picture is identical to it. Though it lowers the highly exaggerated importance of the concept of originality in contemporary art, it does not negate it. Roberta Bernstein pointed out that Warhol's air of distancing himself from the technical process of silkscreening was not borne out by the way he dealt with silkscreening in actual practice: he was always directly involved in the production of his pictures and relativised the mechanical aspect of the medium by printing unevenly.

The artist's strategy has certain subversive features. He undermines the hitherto unassailable importance of uniqueness and originality as criteria for great art – inalienable to the sense of self of contemporary art, whether avantgarde or not. He deceives his critics with an amazing simulation, and still contrives to retain originality as an aesthetic category.

Soon he began to repeat selected subjects on the same canvas. Campbell soup tins are still differentiated by content: a separate picture for each flavour of soup. Sometimes he presents the same subject in different proportions. But in general he utilizes simple repetition, though the repeated subjects do not necessarily fill a whole canvas. In some paintings he prints the subject and its variation, slightly displaced, above one another – now in regular, now in apparently arbitrary arrangements. In addition, he produced numerous versions of almost all these pictures. Even though there is reason to believe that Warhol himself did not really pay close attention to the production process of his pictures, he did make sure that identical pictures within an arrangement could be distinguished, in tone, from one another. He either used different colours to tint the screens or left them unrinsed in order to contrast one composition from any other by intensity or colour density. When he did not vary the colours it is difficult to detect differences. Given that the art world was pleading with vigour and dedication in favour of the principle of innovation, in favour of inventing novel visual worlds, Warhol's paintings must have looked like simple industrial goods, assembly-line products.

Appropriate importance must be assigned to the fact that, initially, Warhol obviously only made use of the technique of silkscreen printing because it was easy. Yet in the beginning he ignored its ability to print individual colour planes so that they fitted perfectly. The edges of pictures are inclined to overlap so one is aware of an optical "jump" between the black-and-white print and the subse-

PAGE 56:
Do-It-Yourself (Landscape), 1962
Acrylic on canvas, 178 × 137 cm
Cologne, Museum Ludwig

PAGE 57:
Do-It-Yourself (Flowers), 1962
Acrylic and silkscreen on canvas,
175 × 150 cm
Reproduced by kind permission of
Thomas Ammann, Zurich

quent coloured one (cf. pp. 51, 53). In spite of slovenly methods and improper use of the tools of the medium, the characteristics of the photo subjects can still be seen in the basic black-and-white print. By contrast to this the strident colouring — streams of brilliant and varied hue — act like a curtain veiling our view of the original image. In portraiture in particular the artist emphasised this characteristic (cf. pp. 40, 41), thus enhancing the marble effect of the sitter's face and even wiping out the last traces of individuality engendered by the photographic pose. He transformed stereotype photographic portraits, which merely simulated individuality, into radiant icons of a godless age, separating the portrait itself from its model and turning it into a mask behind which the longings and fears of the collective soul could hide. On the surface Andy Warhol's works may appear shallow, but this should never be confused with superficiality.
"People look the most kissable when they're not wearing makeup. Marilyn's lips weren't kissable, but they were very photographable." Marlene Dietrich's tormented outcry (on being asked by Maximilian Schell for a long session in front of the camera) "I have been photographed to death!" sounds like an echo of this statement.

From that August till the end of 1962 the artist produced approximately 2,000 pictures. He was now competing with Picasso's legendary output. After he had been offered his first solo exhibition in New York at the Stable Gallery, he moved again, this time into an empty fire station on the East Side, 87th Street. He got to know Gerard Malanga, a young poet, who became his assistant. For $ 150 a month Warhol rented the fire station building which had been scheduled for demolition. Malanga describes the beginning of his artistic career as follows: they started out by silkscreening a portrait of Elizabeth Taylor on a canvas they had prepared by applying a background with silver-coloured spray paint. And, as he put it, although this work was not all that difficult, it got quite dirty somewhat later when the screen had to be cleaned. It must have been the fact that they symbolised certain trends in American society that attracted Warhol to Elizabeth Taylor and Marilyn Monroe, to Elvis Presley and Marlon Brando. They personified the ideals of beauty and success and were themselves synonymous with these attributes. Additionally their stardom was more than partially due to an underlying sexual element, in sharp contradiction to the prudery of the Hollywood films of the 1930s and 1940s. Taylor and Monroe, Presley and Brando radiated a sex appeal which shook the taboos of the conservative American upper class. Warhol himself denied that the sexual element influenced his choice of these people as subjects. In an interview with Gretchen Berg he said that on a few of his pictures, such as those of Marilyn Monroe or Elizabeth Taylor, he did not feel he was portraying the great sex symbols of our time. He said that for him Monroe was just one person among many. And as far as the question of whether it is a symbolic act to paint Monroe in such gaudy colours is concerned, all that mattered to him was beauty, and she was beautiful; and if something is beautiful, then the colours are beautiful. That was everything, he said; that was more or less the way history works . . .

When the artist chose a popular publicity picture of Marilyn Monroe as the subject for one of his paintings, followed by a seemingly endless series of similar portraits – silkscreen with acrylic on canvas or coloured silkscreen graphics on paper – the actress had only been dead for a few days; she had died of an overdose of sleeping pills, apparently after a telephoned cry for help to which nobody had responded. The wildest stories concerning her death were soon being told and Warhol (as though he had sensed that her life and personality were to be marketed in reprehensible ways even by well-known writers who smelled profit) created a memorial which has made this picture of her almost immortal. The picture does not reflect reality, its creative quality is such that the reality in it almost transcends itself. Warhol's painting of Marilyn did not impinge on the private person so constantly sought by the curious. The mask also gives protection. The publicity picture itself – and only this picture – is Warhol's subject. Therefore, his comment that he would not have prevented Monroe from killing herself is not as cynical as it might sound. As he put it, each person should do what he or she wants, and if that made Marilyn happier, she did the right thing.

Big Electric Chair, 1967
Acrylic and silkscreen on canvas,
137 × 186 cm
Reproduced by kind permission of
Thomas Ammann, Zurich

Since the numerous portraits of Marilyn Monroe featured a dead actress (who plainly did not altogether voluntarily depart this life), Warhol numbered them among his death series: pictures of catastrophes and accidents. The painting *129 DIE IN JET* (p. 44) launched this series. Airplane crashes, car accidents (cf. pp. 51–53), poisoning and the electric chair (pp. 59–61) all offered him subjects. Thus this series of pictures is almost a reflection of the opposite to the "American Way of Life" as represented by Warhol's paintings from his commercial period. They also show the artist's peculiar affinity to death. Warhol once said that he realized that everything he did was connected with death – a statement that is frequently quoted. Werner Spies comes to the conclusion that "the main thing about Warhol's art is not his ludic use of clichés, his criticism of consumer attitudes, or his ironical approach to credulity. Rather, the main thing is his attempt to overstep the apparently endless multiplicity of the material things that weigh upon us. That is what his stars and consumer products express. It is not the Monroe death myth; what drove Monroe to her death was this very kiss, the kiss of the world, a kiss that Warhol immortalized – a kiss that symbolized Monroe's function as a timeless trademark." It is tempting to play with such ideas. Does not the habit of unrestrained consumer spending, as constantly encouraged by the appeals of advertising, simply hide the real fears

Electric Chair, 1967
Acrylic and silkscreen on canvas,
137 × 185 cm
Salzburg, Thaddaeus Ropac Gallery

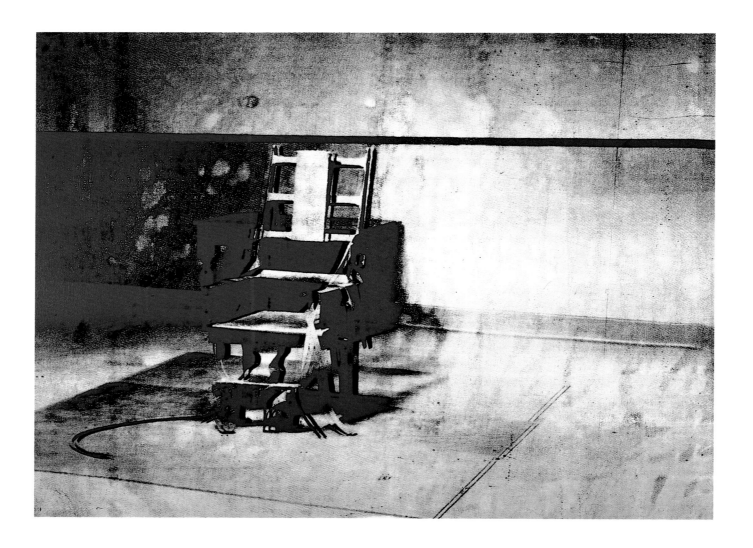

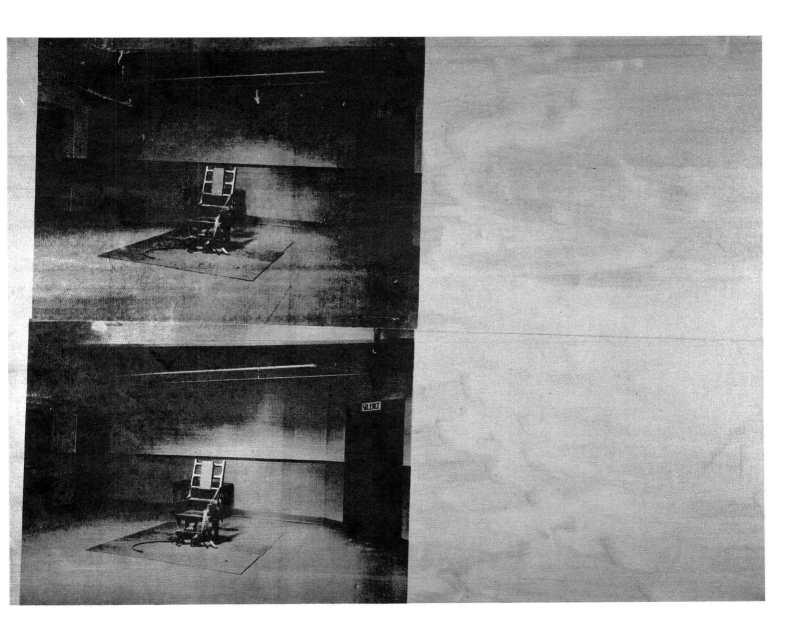

of the affluent society as we approach the end of the 20th century?
The more hectically we throw ourselves into the race to acquire
material things, the more forcefully we thrust aside all knowledge of
our own mortality – and are helped to forget the inevitable. Cosme-
tics, glamorous clothes, sex appeal, all promise eternal youth,
eternal beauty, eternal life. Out of all her publicity pictures Warhol
succeeded in turning one into an icon which allowed Marilyn Monroe
to live on as a symbol of eternal youth. Ironically, the same publicity
shots may have been part of the cause of her loss of life. The visual
image, the picture people are given, becomes more real than the
reality. People adjust their outer appearance and their inner vision of
themselves to these images. Accordingly, dead people in the United
States are cosmetically treated in a way that makes them look more
radiant, healthier and fresher than they did when they were alive. The
artificial freshness engendered by death was to rub off on Warhol
even before he was shot by confused feminist Valerie Solanis on
June 3, 1968. He was to suffer from the aftereffects of this attempted
assassination for the rest of his life. In a very convoluted way Warhol

Double Silver Disaster, 1963
Acrylic and liquitex in silkscreen on canvas,
106.5 × 132 cm
Stuttgart, J. W. Froehlich Collection

"Thirteen Most Wanted Men",
New York State Pavilion, 1964

"Thirteen Most Wanted Men", 1964,
painted over.

was an incredibly precise portrayer of society. He did not portray facts – everybody knows them anyway – he portrayed what the facts concealed: the "inner world" of collective longings and fears.

Today a Cadillac may be a symbol of wealth and happiness, tomorrow it may simply be scrap metal, an ill omen of mortality. It was only shortly before his death that Warhol started painting pictures of immaculate automobiles. Up to then the car as represented in his pictures had been a symbol of violent, senseless and brutal death on the roads. *White Car Crash 19 Times* (p. 51), *Green Burning Car I* (p. 53), *Orange Car Crash 10 Times* (p. 52), *Ambulance Disaster* – these are just a few of his accident pictures. The artist used newspaper pictures which added a piquant horror to unemotional reports of the death of individuals. But does not the ability to wear out quickly or be rapidly consumed confer a built-in obsolescence on material goods almost by definition? The total write-off accident only shortens the process and if the owner of the car survives the accident he will immediately buy a new vehicle. The artist who draws attention to this is not being cynical. Only occasionally do Warhol's death pictures feature a person – such as the young woman who threw herself off the Empire State Building (as others throw themselves into an orgy of spending?) or the women who died of food poisoning after eating tinned tuna fish. Even here one finds the link between the act of consumption and death. In most cases, though, death remains "impersonal." The electric chair, the heap of scrap which had once been a car – they stimulate the viewer's imagination, kindle his interest, for death does not come closer to people by being pictured. He said that his death series consisted of two parts. The first part dealt with famous dead people, the second with people no one had ever heard of. He felt that at some point people should stop and think about them – about the girl who jumped from the Empire State Building, the women who ate the poisoned tuna fish and the people who were killed in automobile accidents. He said it was not that he felt sorry for them, but that people went about their business and in the end they did not really care if some unknown had been killed. So he thought it might be nice for these unknowns if people who normally would not think about them were to do so for once.

The *Thirteen Most Wanted Men* portraits (pp. 63–65) fall into the same category as the death series. The pictures did not come from newspaper photos; they were "wanted" posters from the FBI's criminal records – photos of criminals, taken on the day they were remanded in custody, each shown front and side view, subsequently to be displayed on posters in post offices and police stations. On the occasion of the 1964 World's Fair in New York Warhol had been commissioned by architect Philip Johnson (plainly he had arrived as an artist) to design a large mural for the New York State Pavilion. He used old photos of criminals and placed them on square enamel plates. The 388 foot square mural was mounted on the outside of the pavilion. It provoked an immediate storm of anger which even involved Governor Nelson Rockefeller. The majority of the wanted men were of Italian origin and many of them were no longer wanted.

The State Government feared it would be seen as discrimination against an entire ethnic group. Warhol sprayed the whole mural with silver aerosol paint (cf. p. 62) (having had his counter suggestion of using the unpopular World's Fair director's face in the wanted posters instead rejected). Later he was to use the same subject in a series of paintings on canvas, *Thirteen Most Wanted Men,* which he deliberately painted in accentuated screen dots to give the effect of a printed photo.

The portraits of wanted men are linked – as were the portraits of Marilyn Monroe – to his death series. Portraiture was to prove his most prolific medium. Some of his portraits are the result of private commissions and the artist was never too proud to say no to these. Most of the uncommissioned portraits were generated by special events or the topicality of the subject. But the one thing all of his portraits have in common is that they represent prominent people: artists, collectors, film stars, politicians – and criminals. In a media-conscious society, fame is almost a natural indicator of social success and even a criminal in the United States enjoys social prestige, as long as he is successful. In his own lifetime Al Capone was one of the most popular figures in his hometown of Chicago; he once came third in a most popular citizen poll. The end justifies the means. Warhol's infallible sensitivity to subliminal social trends can be best observed in his portraits, a puzzling "Galerie Contemporaine" of figures, both as individuals and as symbols of a society

ABOVE LEFT AND RIGHT:
Most Wanted Man No. 10 (Louis M., front), and
Most Wanted Man No. 10 (Louis M., side), 1963
Silkscreen on canvas,
122 × 100 cm each
Mönchengladbach, Abteiberg Museum

PAGE 64:
Most Wanted Man No. 11 (John Joseph H., side), 1963
Acrylic and liquitex, silkscreen on canvas,
122 × 101.5 cm
Frankfurt am Main, Modern Art Museum

PAGE 65:
Most Wanted Man No. 11 (John Joseph H., front), 1963
Acrylic and liquitex, silkscreen on canvas,
122 × 101.5 cm
London, Saatchi Collection

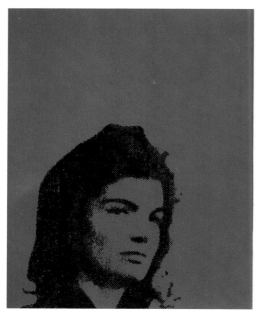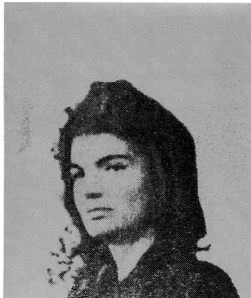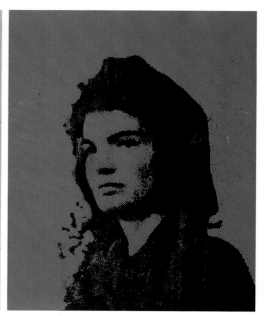

Jackie Triptych, 1964
Silkscreen on canvas, three frames,
overall 53 × 124 cm
Cologne, Ludwig Collection

OPPOSITE:
Four Jackies, 1964
Silkscreen on canvas, 102 × 81 cm
New York, private collection

which was at a turning-point in its evolution. Only a few years after producing *Thirteen Most Wanted Men,* Warhol had himself achieved a place in the line-up of successful contemporaries, the only one from the world of art to reach the top echelons of the world of stardom.

The news picture of Jackie Kennedy crying beside the coffin of her assassinated husband, President John F. Kennedy, shook the media world possibly even more than had done the assassination itself. Andy Warhol used it in different versions (pp. 66–68) and at least five different photographs were used as subjects. Jackie Kennedy, the spoiled little rich girl of French extraction, personified the nation's hope of a union between politics and culture. She had seemed to be the incarnation of a new Madame de Staël. The picture of the mourning widow abruptly destroyed the mood of freedom and change for the better which had swept the U.S.A. during the Kennedy era. It became a symbol which tragically altered our view of the past. Warhol also used Jackie Kennedy for one of those few pictures which departed from his usual approach – a narrative picture which tells the story of a happily smiling young woman, suddenly turned into a grieving widow. Time passes in this picture – a device that is contrary to almost all his previous techniques (with the exception of one earlier sequence, which describes cosmetic surgery using the device of "Before – After"). In general Warhol made use of only one single photographic image, and dividing the canvas into different planes, he either constantly repeated the image or altered it by shading a large part of it in monochrome. In these pictures time literally stands still; they repeat the same instant in time as if they wanted to capture the moment – paradoxically in continuity. Werner Spies understood the subliminal fear of life that lay behind this attempt to make time stand still: "Even his many cats, all called Sam, fit into the picture: 'My apartment had four floors, plus a living room with basement where we had the kitchen and where my mother lived

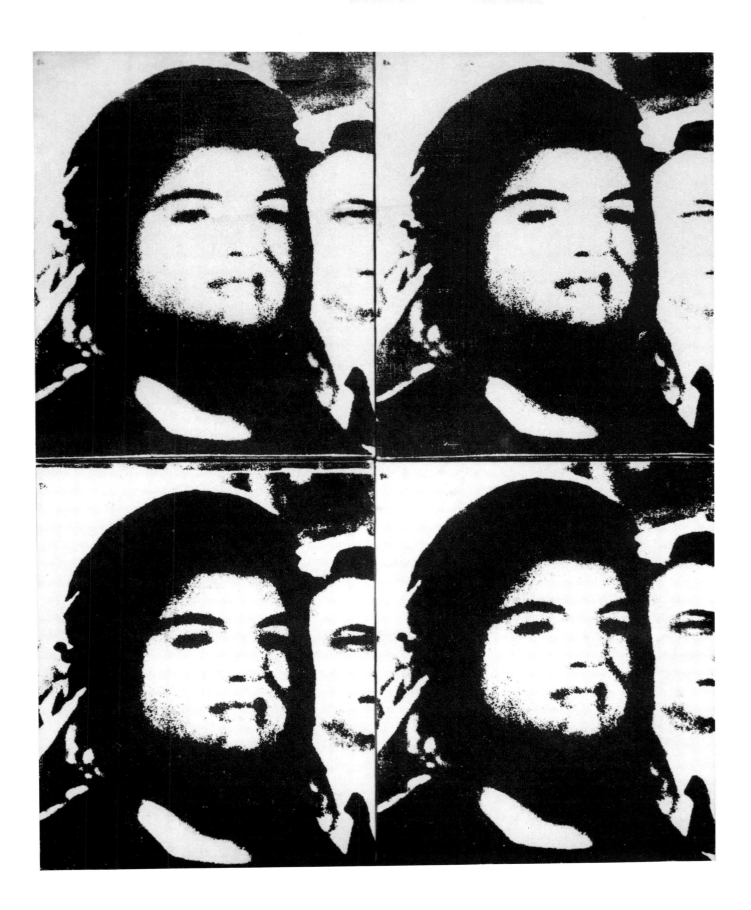

Jackie III, 1966
Silkscreen on paper, 101.6 × 76.2 cm
Edition: 200 sheets
From the portfolio *Eleven Pop Artists III*
Publisher: Original Editions, New York

with a lot of cats; they were all called Sam.' Calling them all Sam is more than a joke, it has a question of calculated insurance against unhappiness, just as Samuel Beckett demonstrates in his novel *Watt.* Here it is Mr. Knott's obsession that one day there might be no dog to lick Mr. Knott's dish, filled with left-overs. Thus he keeps the Lynch family who are merely responsible for looking after the many hungry dogs who are to be substitutes for the first dog once he dies . . . and in case the Lynch family might not satisfactorily fulfil their task, Mr. Knott keeps another 'happy Lynch family' and behind them other 'happy Lynch families' and so on, ad infinitum."

The four-frame portrait of Jackie Kennedy, with laughing and with mourning face, indicates the transient nature of happiness. By using uninterrupted repetition Warhol's art depreciates the unique quality of happiness as well as of unhappiness. Continual reiteration undermines the exceptional nature of the original subject matter. Its uniqueness is dissolved by virtue of repetition, it loses its contours, fades and by fading brings into force a world cloaked by the constant barrage of the mass media. Spies rightly speaks of overstepping the subject matter. "Here it turns out that Warhol's structure of repetition leads to the attrition of the articles themselves and their character. Reiteration gnaws at the entire picture. In some of his more memorable pictures Warhol managed to capture the desolation of repetition, the destruction of feeling by overexposure and of enjoyment by consumption."

OPPOSITE:
Atomic Bomb, 1965
Acrylic and liquitex, silkscreen
on canvas, 264 × 204.5 cm
London, Saatchi Collection

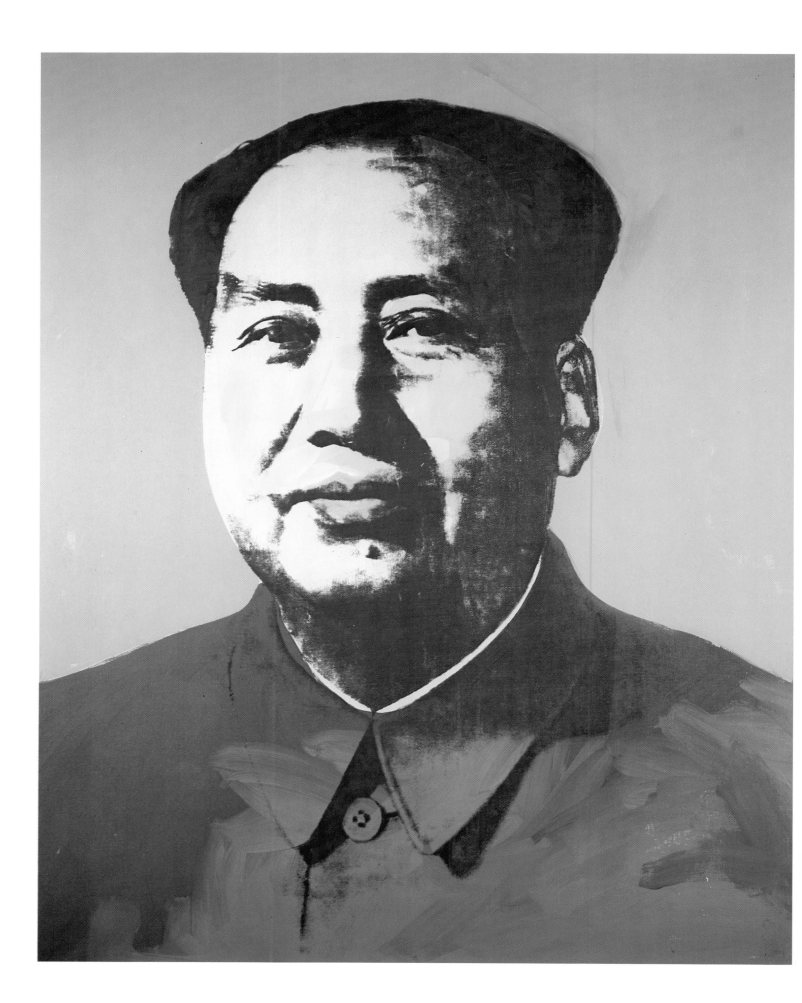

From Underground Film Maker to Affluent Collector

In 1963, even before he was sharply criticised for his Brillo cartons – for they, even though made of wood, too strongly resembled the soap pad company's real packaging (pp. 34–39) – and before his mural *Thirteen Most Wanted Men* (pp. 62–65) gave public offence, Warhol had bought a cine camera and a tape recorder. In the same year he moved to 47th Street and finally in November, 1964 Leo Castelli arranged the first exhibition for him and Robert Rauschenberg. For this exhibition Warhol selected a flower series which had already been shown – at Ileana Sonnabend's in Paris in January (cf. pp. 42, 72–74). "I thought the French would prefer flowers, because of Renoir and so on," Warhol observed. Gerard Malanga said that Warhol had come across the picture in a botanical catalogue and told him to make a silkscreen print out of it. A lady recognized the photo of her poppies and thought Warhol should have compensated her for it. Malanga said he could see her point. It took years until the matter was finally settled. Warhol had stolen an amateur photographer's picture and had – by accident? – uncovered the close link between his own artistic conviction and the amateur photographer's attitude towards visible reality. Almost everything is worth depicting, everything is available; it is just that the audience naturally prefers the work of the well-known artist to that of the unknown amateur. In the Factory, which his home on 47th Street had turned into, a woman suddenly appeared – shooting a pistol at the portraits of Marilyn Monroe.

Warhol enjoyed life in the group that had slowly formed in his apartment (some of the people living there only temporarily and being involved in varying tasks). It was a collection of young people from differing social backgrounds united by one thing: dislike of convention and the Establishment. Flipped homosexuals, lesbians, artists, film makers, students, actors, poets – this mixture of creative people and scatterbrains, of curious individuals and freaks who liked to experiment, created an electric atmosphere, where ideas grew like tomatoes in a greenhouse. And yet they worked hard; the Factory's productivity was enormous. Just as a bee sucks honey, Warhol sucked ideas and was stimulated by their various talents. When he developed an idea worthy of production, he gave his "boys and girls" a free hand, although guiding them in the right direction.

Official photograph of Mao Tse Tung

OPPOSITE:
Mao, 1972
Acrylic, silkscreen and oil on canvas,
208 × 157 cm
Reproduced by kind permission of
Thomas Ammann, Zurich

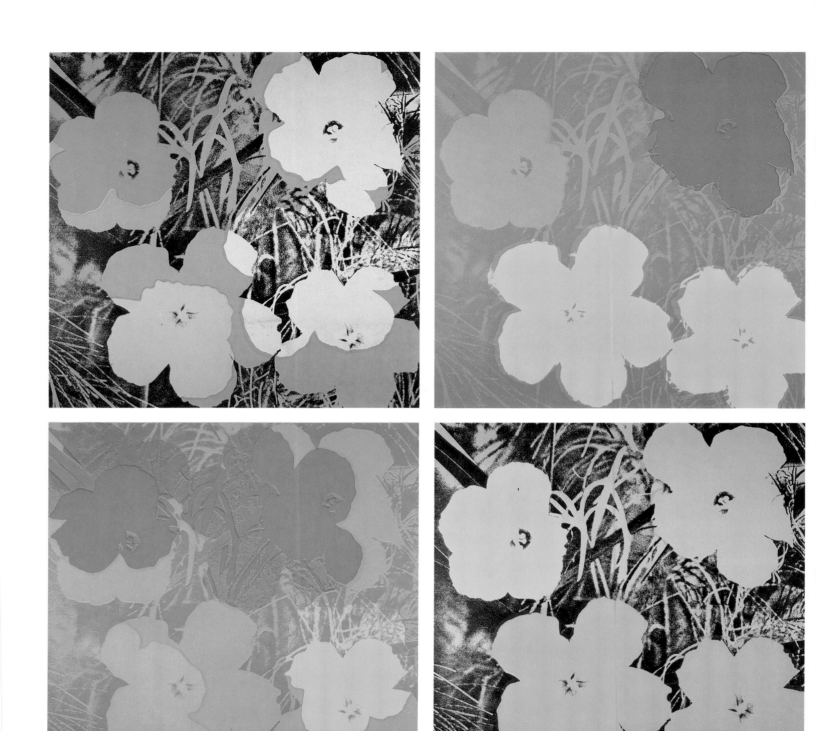

PAGES 72 TO 74:
Flowers, 1970
Portfolio of 10 silkscreen prints
Size: 91.5 × 91.5 cm
250 copy edition of artist's proofs
numbered with a stamp, signed and marked
form A–Z on the back in ball point
Publisher: Factory Additions
Reproduced by kind permission of
Neue Galerie – Ludwig Collection, Aachen

The Factory, however, was not a factory in the true sense; it was not an industrial enterprise. It can more truly be compared with the studios of artists such as Verrocchio, Leonardo, Cranach, Titian, Rubens or Rembrandt. Nothing went out of the studio door that had not received the master's explicit seal of approval. Warhol fascinated and stimulated this group of strange characters and they in turn served him as recipients and mediums of something which, for lack of a better term, can be defined as "the spirit of the times." With the help of this group of people he could feel the pulse of what was going on in the world around him, helping him to react like a seismograph

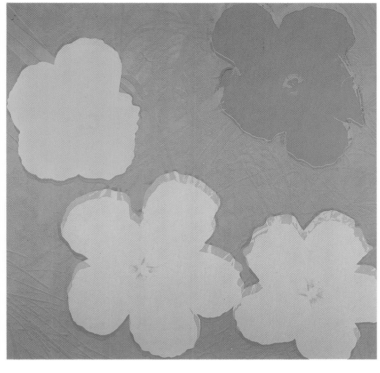 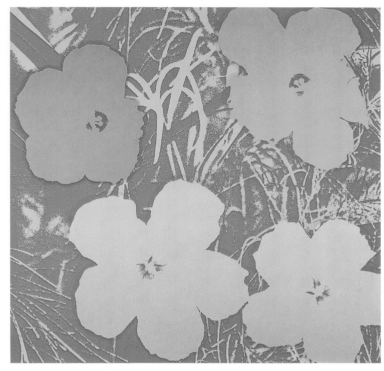

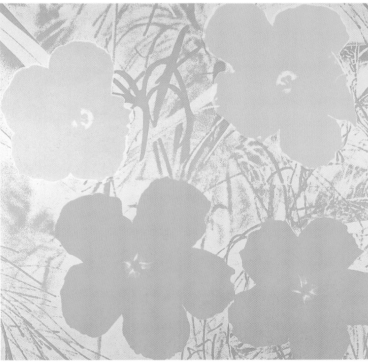 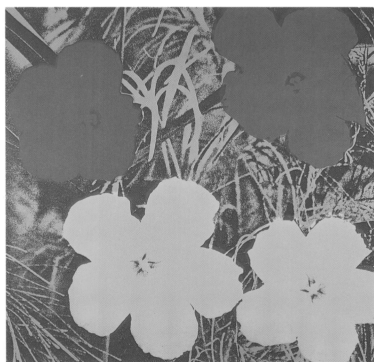

to the development of fashionable trends. In addition, the Factory soon became a focus for the active art scene, especially those in the know. "Famous people had started to come by the studio, to peek at the on-going party, I suppose – Kerouac, Ginsberg, Fonda and Hopper, Barnett Newman, Judy Garland, the Rolling Stones. The Velvet Underground had started rehearsing in one part of the loft, just before we got a mixedmedia roadshow together and started our cross-country in 1963." Those who visited the Factory were surprised at the great industriousness of the studio and that one artist in the background managed to control the apparent chaos.

"The most beautiful thing in Tokyo is McDonald's.
The most beautiful thing in Stockholm is McDonald's.
The most beautiful thing in Florence is McDonald's.
Peking and Moscow don't have anything beautiful yet."
ANDY WARHOL

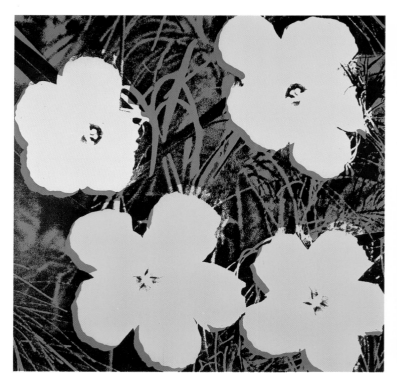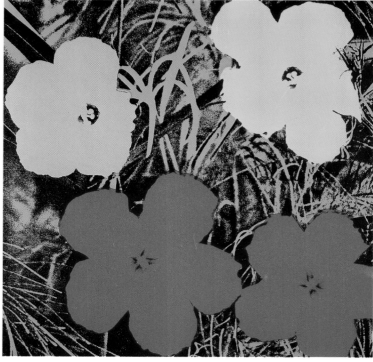

The stars of his films were taken from his crew at the Factory.
Hardly any of them had studied acting for the cameras and they did
not, in fact, need a drama school education. For in the beginning
Warhol's films mainly concentrated on the simplest proceedings and
events: *Sleep* (1963) was his six-hour film debut and shows a
sleeping man while the camera slowly moves over individual parts of
his body. Actually the film itself consists only of 20 minutes, the rest
being repetition of the first sequence, repeating the technique of his
silkscreen pictures. *Empire* (1964) presents an eight-hour view of
Manhattan's pride, the Empire State Building, photographed from the
44th floor of the Time-Life Building. Warhol had chosen Jonas Mekas
as cameraman for this film because he knew how to operate the
Auricon camera which Warhol had bought. The film portrait of Henry
Geldzahler shows the art connoisseur smoking a cigar – for 100
minutes. Warhol said that the first films he made with stationary
objects were not least of all supposed to help the people in the
audience to get to know each other. As he put it, people sitting in a
movie theatre usually find themselves in a phantasy world; and if
they see something that is disturbing to them they will be more likely
to turn to the person sitting next to them. He found that films were
more suitable for this than plays and concerts, where one simply has
to sit there. Only with TV was it possible, in his eyes, to accomplish
more than with film. He claimed that one could do more while
watching his films than when watching other films: one could eat and
drink, smoke, cough and look away and then look back again and
always find that everything was still there.

His films literally turned the conventions of the Hollywood narra-
tive film upside down: boringly long sequences, uncut, with little or
no change of image or focus, using the Auricon camera (which could

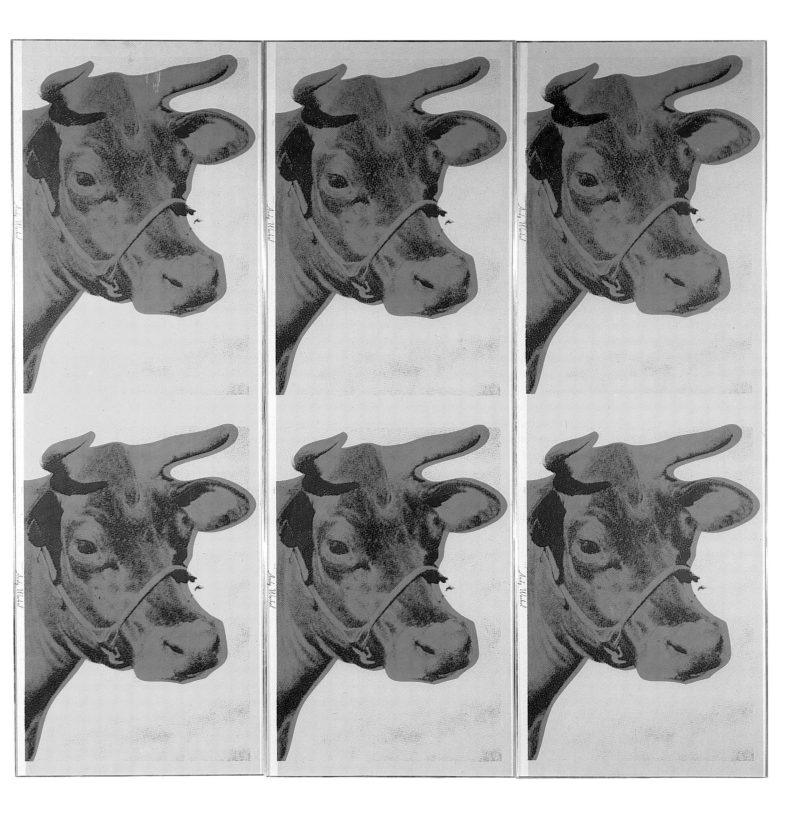

record picture and sound at the same time) meant that one was confronted with aimless talk, irrelevant sentences from day-to-day-life, instead of sharp dialogue. Sloppy camera work, amateur panning, careless use of sound – there was no law of film making that Warhol did not violate. The themes of his films were unspeakably banal, the "stars" acted (if they were not asleep or, like the Empire State Building, made of glass and concrete) with the exaggerated gestures of amateur actors. But it was the seeming clumsiness – partially due to lack of professionalism, partially to the use of delib-

Cow Wallpaper, 1966
Silkscreen on paper, 112 × 76 cm each
Unlimited edition
Publisher: Leo Castelli
Reproduced by kind permission of
Neue Galerie – Ludwig Collection, Aachen

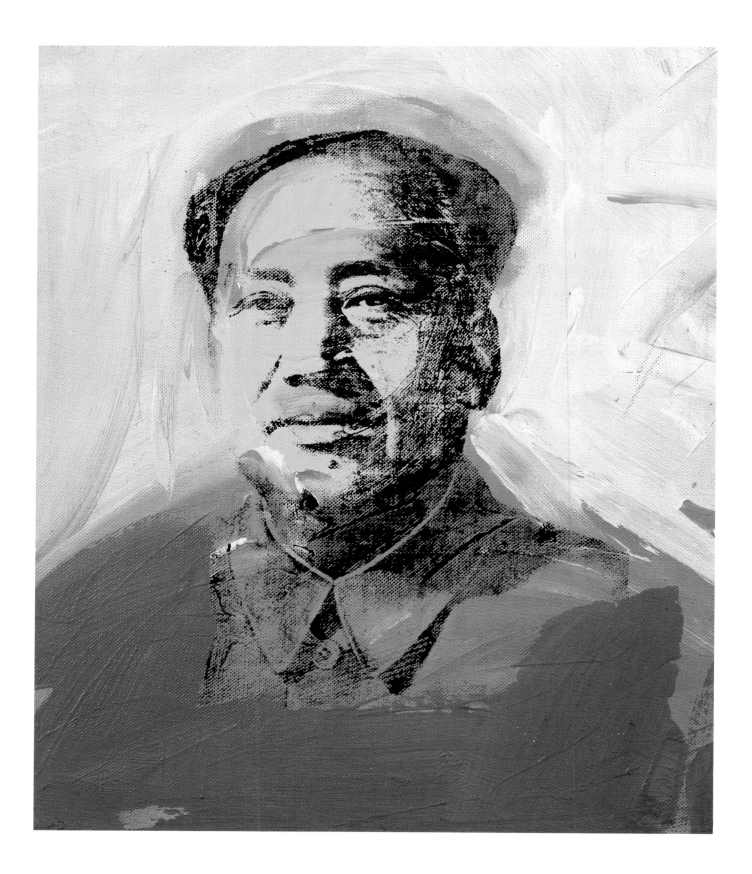

Mao Tse Tung, 1972
Silkscreen and oil on canvas,
128 × 107 cm
New York, private collection

erate, conscious, stylistic device — which made them strikingly immediate and fresh. If the cinemagoer really concentrated and became involved in these films, they had an incredibly forceful effect. Offering utterly meaningless trivia, they took an attentive audience out of the real world of purpose and constraint and induced a mood bordering on the ecstatic — whilst still in a state of consciousness. Warhol's films build up an explosive effect and come alive, seen

76

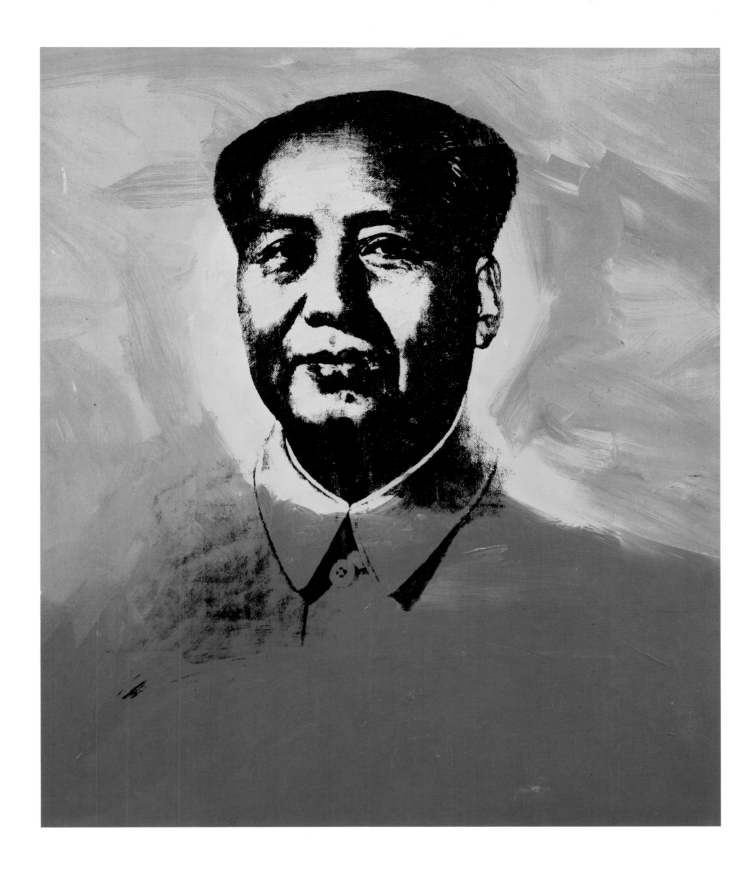

against the background of the narrative film tradition of Hollywood and its cliché drama. Consciously ignoring every rule, Warhol unmasks them as empty shells filled with a manifest and lively reality. And yet his films would be unthinkable without the traditional film to hold them up against; they are shaped by their deliberate contrast to the Hollywood approach and benefit from its myths. This is the explanation for the persistent quality of aliveness that permeates any

Mao Tse Tung, 1973
Acrylic and silkscreen on canvas,
30.5 × 25.5 cm
Salzburg, Thaddaeus Ropac Gallery

"A big rock star might sell millions and millions of records, but then if he makes a bad movie, and when the word gets around that it's bad, forget it."　ANDY WARHOL

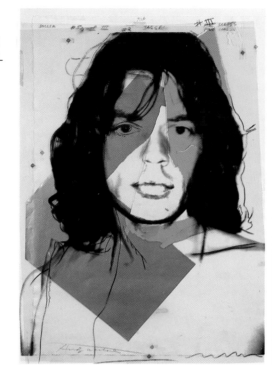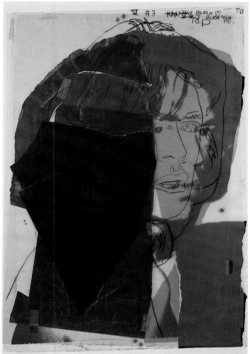
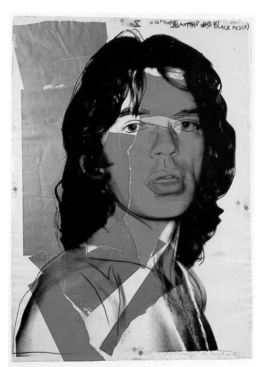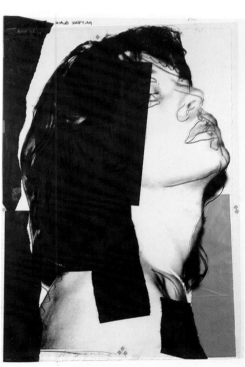

Mick Jagger, 1975
Portfolio of 10 silkscreen prints
Size: 111 × 73 cm
250 copy edition numbered and
signed in felt pen
Publisher: Seabird Holding Ltd.
Reproduced by kind permission of
Neue Galerie, Aachen – Ludwig Collection

underground film documenting reality in all its contradictions and imperfections – in contrast to the Hollywood film, whose professionalism is aimed at reflecting a reality more real than reality itself. Thus Warhol's "stars" were a striking contrast to the stars of the Californian film world. And Warhol even involved the audience in his films by using unusual forms of projection to pull them out of their contemplative viewing attitude – some films were projected next to each other, some above each other. The more he perfected his craft the closer became his links to the Hollywood film – a paradoxical consequence.

78

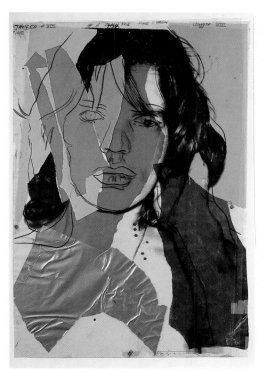 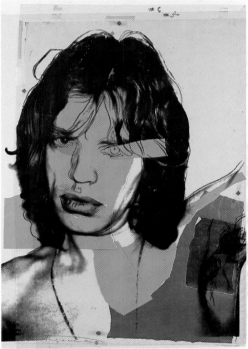 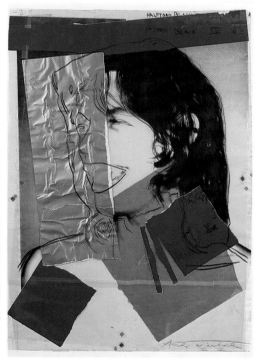

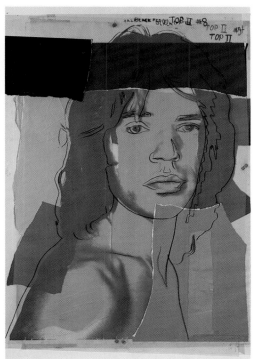 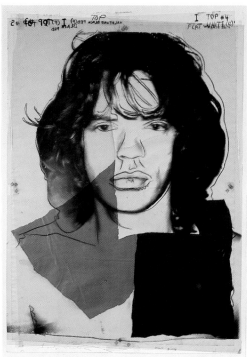 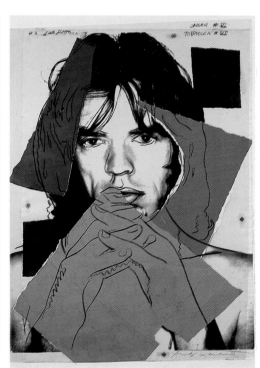

His first commercial success was *Chelsea Girls* (1966), a panorama of scenes consisting of five chapters. The focus of attention – though not the only scene – was the Chelsea Hotel, mainly visited by artists, writers and musicians. Roland Tavel wrote the script for the chapter "Hanoi Hanna (Queen of China)"; the other chapters were improvised by the "superstars" of the Factory, with marked humour and directness. Jonas Mekas describes the effect in the following terms: You watch a Warhol film without being hurried. From the very beginning it prevents the viewer from being in a hurry. The camera hardly moves from the spot. It remains focussed on the

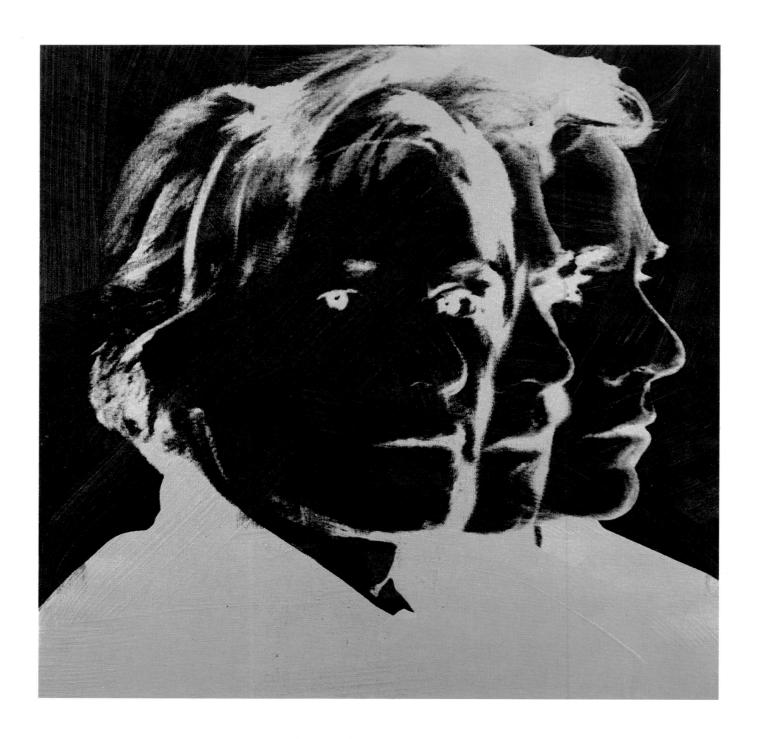

Self-Portrait, 1978
Acrylic and silkscreen on canvas,
106 × 106 cm
Salzburg, Thaddaeus Ropac Gallery

subject as if there were nothing more beautiful and important than this subject. We can look at it longer than we are accustomed to doing, and this gives the viewers an opportunity to clear their minds of everything. We begin to understand that we have never really seen what happens when hair is cut or how one eats. Although we have had our hair cut and we have eaten, we have never truly perceived the act of haircutting or eating. The whole reality of our environment suddenly becomes interesting in a new way, we feel that everything has to be filmed in a new way. After *Chelsea Girls* Warhol handed over more and more of the film work to his assistant Paul Morrissey; the films from the Factory became more professional and at the same time more conventional as they slowly adopted the aesthetic patterns of the narrative film. *Flash* (1968) and *Trash* (1969) thus became big box-office successes.

80

Andy Warhol's film techniques are linked to those of his printed pictures, particularly in the use of repetition, the reiteration of identical photographical subjects within a frame. The technique of film making is technically the same: the "moving" picture consists of a certain number of individual frames, which at the unwinding of a film reel melt into one another, appearing thereby (to the human eye) to create movement. More than in static paintings on canvas Warhol saw possibilities in this technique, ways of reaching a far higher frequency of repetition: especially when he focused the camera on a static object or almost motionless people. But here the physiological statement of the effect of repetition is changed, for in a film the fixed moment is intensified, endures and is not in any way devalued. While Warhol's printed pictures were the result of a fear of life (according to Spies) his films make evident a secret fear of death, conjuring up a Faustian need to hold on to the fleeting moment. Fear of life – fear of death: in Andy Warhol's art these two basic feelings complement one another, as paradoxical as this may seem, and they are the basis of his beliefs in life and art. In fact an actual assassination attempt

Black on Black Retrospective Reversal Series, 1979
Acrylic and silver print on canvas,
195.5 × 241.3 cm
Reproduced by kind permission of
Galerie Bischofberger, Zurich

was to be made on Warhol's life when on June 3, 1968 Valerie Solanis (only representative of S.C.U.M., the Society for Cutting Up Men) attempted to shoot him dead. Following major surgery he had to spend two months in hospital; the two bullets had penetrated his lungs, stomach, liver and throat. Critic Mario Amaya, who happened to be present in the same room, was shot in the hip. "I always worry that when nutty people do something, they'll do the same thing again a few years later without ever remembering that they've done it before – and they'll think it's a whole new thing they're doing. I was shot in 1968, so that was the 1968 version. But then I have to think, 'Will someone want to do a 1970s remake of shooting me?' So that's another kind of fan." (Warhol) A truly frightening insight into the risks a star is exposed to in a world in which he himself needs to survive. Marlene Dietrich's words echo in our mind: "I have been photographed to death!" More often metaphoric 'death' is the result of fame – rather than physical death, as in the case of John Lennon. For is not the star, by definition, not a physical being but merely an apparition existing only in the firmament of human dreams and longing?

Still Life, 1976
Acrylic and silkscreen on canvas,
183 × 208 cm
New York, Leo Castelli Gallery

Gun, 1982
Silkscreen on canvas, 178 × 229 cm
New York, Leo Castelli Gallery

While Paul Morrissey took care of the Factory's film production, Warhol began intensive work with the rock band Velvet Underground and together they produced a multi-media show which included music, dance, light, slide and film projection and the appearance of a German singer, actress and fashion model, Nico. The same year saw his last exhibition of "conventional" art at Leo Castelli's. He pasted the walls with picture wallpaper decorated with the incessant repetition of a single motif: a cow (p. 75); flying sculptures of silver-coloured balloon cushions – the "Silver Pillows" – were floated into the air. In 1967 he paid tribute to Marilyn Monroe with a series of silkscreen prints, arranged in sheets of 10 in portfolios, and he exhibited the *Thirteen Most Wanted Men* as a complete series at Ileana Sonnabend in Paris. In the same year he moved, together with the Factory, to Union Square West and at Expo '67 in Montreal he exhibited six self-portraits. Together with Gerard Malanga he published a diary, a year later: *The Andy Warhol – Gerard Malanga Monster Issue* and the novel *A*, the exact rendering of a 24-hour tape recording of sounds and discussions at the Factory. His amazing artistic spectrum also included a stage set, "Clouds," created for the ballet *Rainforest*, choreographed by Merce Cunningham in 1970. John Wilcock persuaded him to publish a new magazine and *Inter/View* became

U.S. Dollar Sign, 1982
Silkscreen on canvas, 220 × 178 cm
New York, Leo Castelli Gallery

the most popular mouthpiece of the world of Warhol. As a star among stars, as a permanent guest at the most important parties in New York, he met the celebrities of his time including Elizabeth Taylor, Liza Minelli, Marisa Berenson, Muhammed Ali, Paulette Godard,

Erich Maria Remarque's widow and the former wife of Charlie
Chaplin, Willy Brandt, Henry Kissinger, Ginger Rogers and so on.
Celebrities competed to have their portraits done by him, the master
took their photos with his polaroid, his constant companion, and then

Parrot, 1984
Silkscreen on canvas, 25.5 × 20.5 cm
Wendlinghausen, private collection

Campbell's Noodle Soup, 1986
Silkscreen on canvas, 35 × 35 cm
Salzburg, Thaddaeus Ropac Gallery

left his Factory to turn them into pictures. "If he is not at the White House or in Halston's Apartment you can find him in the New York discotheque Studio 54," a contemporary report said. "He could afford to behave as he pleased," claimed Eva Windmöller in an article in 1987. "For instance at Hyannis Port, the Kennedy summer residence on Cape Cod, Massachusetts, in April last year there was a high-class array of guests for the wedding of Maria Shriver, TV reporter and niece of John F. Kennedy, to Hollywood star Arnold Schwarzenegger. Distinguished gentlemen, ladies with flowered hats and a crowd in front of the Church of St. Francis Xavier to watch the cream of the New England establishment go in. An elite mixture of power, money, beauty and fine living. 'The Clan' – 19 Kennedys, 5 Lawfords, 11 Shrivers – are already inside the house of God, the

doors are closed, the organ sounds. And then suddenly there's the luxury limousine, 25 minutes late, and out steps an incredible couple: pop singer Grace Jones, in a strident purple fur and Andy Warhol in black leather, the inevitable rucksack on his back. 'There he is,' shouts the crowd, 'now the show can begin.'"

In an interview with Gretchen Berg at the end of the Sixties, Warhol had proclaimed that he did not paint anymore; he had given it up about a year ago and was only making films. He said he could be doing two things at once, but films were more interesting; painting was nothing more than a phase he had gone through. In fact, however, he only gave up painting for a short time. Rather he opened a new chapter in his work as regards subject and form: with the portrait of Chinese communist leader Mao Tse-tung in the early

Campbell's Onion Mushroom, 1986
Silkscreen on canvas, 35 × 35 cm
Salzburg, Thaddaeus Ropac Gallery

Details of Renaissance Paintings
(Leonardo: The Annunciation), 1984
Acrylic on canvas, 122 × 183 cm
Munich, Galerie Bernd Klüser

Seventies (pp. 70, 76, 77). Warhol emphasised the hand-painted part of his work, stressed the brush stroke at the cost of the printing technique, by partially integrating oil painting into his silkscreen pictures, and played down the mechanical effect. But the subject of this series of portraits was taken from the official photographic print of the almighty party leader, which hung on every Chinese wall. But still the studies differ from one another in colour as well as in composition and in the selection of detail. By means of a lighter colour scheme the head sometimes stands out against the painting's coloured background and the contrast of colours generates a kind of halo. In the artist's eye this charismatic politician ranks with stars, superstars and megastars – for in the wake of the student revolution of 1968 Mao had become a cult figure. His popularity in the Western world, the passionate enthusiasm he had kindled among certain young demonstrators in America and Europe, and also the commercialization of his portrait as well as *The Words of Chairman Mao* (the famous Little Red Book, published in print-runs of millions), was reason enough for Warhol to portray the Chinese leader. It was not the historical importance of this figure that stirred Warhol's interest, but his reception in Western capitalist society. Mao had become a socio-psychological symbol of a certain outlook on life, just as had Mick Jagger, lead-singer of the rockband The Rolling Stones, in a

Details of Renaissance Paintings (Uccello:
St. George and the Dragon), 1984
Acrylic on canvas, 122 × 183 cm
Munich, Galerie Bernd Klüser

different context, whose portrait also found its place in Warhol's
gallery of famous heads (pp. 78, 79) and just as had Willy Brandt, the
West German chancellor. Anyone the media world made into a star
was eligible to join that gallery, regardless of social position or
profession. Leo Castelli (p. 43) was among the chosen ones as was
Joseph Beuys; dead "heroes" too, such as Franz Kafka, Sigmund
Freud, Golda Meir and George Gershwin who were united in 1980 in
the series *Ten Portraits of Jews of the Twentieth Century;* likewise
Goethe, Alexander the Great and Lenin (retrospective stars, so to
speak) – a bizarre mixture, which illustrates the wide horizons of the
media world at the end of the 20th century. Art historian Robert
Rosenblum called Warhol the "court painter of the 70's." With his
polaroid Andy Warhol took pictures of most of the celebrities he met,
as potential subjects for his silkscreen portraits. He was an extremely
accurate observer of this society and at the same time part of it.
Photographer Helmut Newton, who took a disturbing picture of the
artist, resembles Warhol in his powers of observation, as did the late
Truman Capote and fellow-author Norman Mailer.

Without doubt Andy Warhol himself had become a superstar of
the media world. He contributed to it by producing no less than six
different self-portrait series and in 1981 he placed himself among
American legends such as Mickey Mouse, Uncle Sam and

"They always say that time changes things, but you actually have to change them yourself." ANDY WARHOL

Superman. "When I did my self-portrait, I left all the pimples out because you always should. Pimples are a temporary condition and they don't have anything to do with what you really look like. Always omit the blemishes – they're not part of the good picture you want." He was annoyed when Campbell changed its brand image and he painted new pictures of its noodle, tomato and onion soups (pp. 86, 87). But time took its toll, it had left his consumer icons behind: even the ways in which we consume our food is subject to changes in fashion. On the other hand, Warhol changed the Hammer and Sickle, the Communist emblem, into a cheap trademark – long before it was printed on T-shirts – by slightly turning it to the right (by which it lost some of its threatening impact) (p. 82). And while Leonardo da Vinci's *Last Supper* was being restored Warhol presented a substitute to his audience – painted on big canvasses using silkscreen technique and in varying versions (p. 91). In the *Cars* series he celebrated the famous German automaker Daimler-Benz. Cologne Cathedral, the palaces of Bavaria's King Ludwig II, the dome of light created by Albert Speer on the occasion of the Third Reich's party rally in Nuremberg – the subjects of Warhol's later works changed incessantly, and it is difficult to see the criteria by which they were selected. This hectic production seemed to have been determined by a subliminal fear that time was running short. Warhol ate up the whole world like a greedy man afraid of life as a result of his hidden fear of death. Everything was beautiful, everything became a picture. Health farms in Dallas, Texas, beauty treatments in Denver had levelled everyone out, had removed the spots from their faces. Everything was not merely "pretty" but also indistinguishable, like the artificial products of the food industry. The world of the consumer is paradise on earth. At the end of his life it seemed as though Andy Warhol had been infected with a virus. The urge to collect (mentioned by many of his friends) was one of its symptoms. Almost every day he went out to browse through antique shops. He collected indiscriminately – and he consumed what he purchased without using it. Art and life finally faded within him. Or did they cancel each other out? The Factory, moving several times from one place to another, still produced incessantly; week after week the magazine *Inter/View* (whose shares Andy Warhol had sold) propagated his universe; with an ordinary camera he took pictures of celebrities, such as Truman Capote, his first love, girls in underwear or the dogs of the rich, and he stitched together in fours the limited (!) prints of his photos. He was totally immersed in the material world and its uniformity, the world of easy money and rapid success, of the Here and Now, when he unexpectedly died as the result of routine surgery in a New York hospital. According to Eva Windmöller, Bob Colacello, Warhol's friend and former chief editor of "Inter/View", claimed that Warhol always wanted everything to be exactly the same and that multiplication through repetition was part of his philosophy. He would apparently wear the same jacket for years until the pockets, always stuffed full, fell off. He would eat the same thing for lunch every day until one day he would have something completely

different and could never understand why he had ever eaten the old lunch. At the beginning of the Seventies he obsessively recorded everything, 24 hours a day, but it was mostly just noises. He kept everything he could get his hands on. He wanted to stretch time to eternity. When death overtook him he was already a legend.

Last Supper, 1986
Acrylic and liquitex, silkscreen on canvas,
101.5 × 101.5 cm
New York, Spiegel Collection

Conclusion

More than any other, Andy Warhol was an artist of his time; a dispassionate observer, with an ambivalent outlook; not a revolutionary, but one who yet made changes of enormous impact. As a Pop artist – the only true one, who fought so hard to gain his artistic reputation – he saw contemporary art and the art world move into a new era. He was not always the initiator of new ideas; often he drifted along, taking advantage of a sudden impulse. But he had a highly developed personal radar which enabled him to register latent social trends and expectations earlier than his contemporaries. He used art as a means of bringing to the attention of the masses facts and ideas which afterwards seemed so obvious as to make it surprising that so few really saw them. Nothing he created was unknown before; he did not invent anything – except that one might say that in creating Andy Warhol he invented the first art Pop Star. With his legendary Factory (today still working for the Warhol Foundation) he reintroduced the old idea of the artist's working studio, but as applied to a modern artist running under different rules. He was not the master who provided his assistants with bread and work, but a 'first among equals' who employed a host of temporary assistants. Thus the subtle analogy of a court painter as seen by Rosenblum is not applicable to him. After the Second World War any resemblance to the earlier days, based on capitalist patrons promoting the hopeful young artist, had vanished and been replaced by a society consisting mainly of classless workers – a fact reflected by both advertising and consumer behaviour.

Warhol was no visionary, no suffering genius. He personified a kind of professional artist manager who made all forms of media work for him and who did not shrink from using trivia. He was, in fact, a producer of software for a form of art which paralleled the social system, a conceptual artist who, at the same time, produced hardware promoting his own image as an artist. Warhol reacted immediately to the challenges of his time and gave a new dimension to the world of art, but without hurting its sense of self. At least so it seemed. But his apparently affirmatory artistic strategy had its subversive features, for it uncovered the hidden mechanisms of the modern industrial, consumer and leisure rich society and it exposed connections usually only visible through in-depth analysis. He was a spirit who always said 'yes' and his work shrinks the world to what is recognisable (as Brecht once put it). Through his contribution art is no longer what it was. By avoiding the problems of the avant-garde, he brought art back onto its feet, though at a price, as he undermined its claim to autonomy. Since Warhol, the epoch of bourgeois art has come to an end because as soon as autonomy was accepted, the predominant concept of art was lost.

"I really do live for the future, because when I'm eating a box of candy, I can't wait to taste the last piece. I don't even taste any of the other pieces, I just want to finish and throw the box away and not have to have it on my mind anymore." ANDY WARHOL

Joseph Beuys, 1986
Acrylic on canvas, camouflage,
254 × 203.5 cm
Munich, Bernd Klüser Gallery

Andy Warhol 1928–1987
A Chronology

1928–1931 Born between these dates. Versions of the actual date vary. Warhol himself claimed that his 1930 birth certificate had been forged. He was born under the name of Andrew Warhola in Forest City, Pennsylvania, the son of miner and construction worker Ondrej Warhola and his wife Julia. In 1912 his father had emigrated from Czechoslovakia to the United States, his wife following nine years later. Andrew had one older and one younger brother.

1933 Enrolls in elementary school.

1942 Death of his father after a three-year illness.

1945 Finishes high school.

1945–1949 Studies at Carnegie Institute of Technology, Pittsburgh, as a working pupil. Meets Philip Pearlstein, a fellow student. During the summer holidays he works in a department store.

Andy Warhol, 1958
Photo: Duane Michaels

1949 In June graduates as a Bachelor of Fine Arts. Moves to New York and lives in an apartment at St. Mark's Place, Lower East Side. Works as a commercial artist for *Vogue* and *Harper's Bazaar* and produces his first advertising drawings for the well-known shoe manufacturer I. Miller. This is also the year he creates his original window-dressing for Bonwit Teller (p. 18). Shortens his name to Andy Warhol.

1952 First solo exhibition at the Hugo Gallery in New York.

1953–1955 Designs the scenery for an off-Broadway theatre group. Dyes his hair the straw colour which until the day of his death was to be his image all over the world. Together with his mother and several cats he moves into a house on Lexington Avenue.

1954 First group exhibition at the Loft Gallery, New York.

1956 First solo exhibition of his drawings for the *Boy Book* at the Bodley Gallery, exhibition of *Golden Shoes* on Madison Avenue. Goes on a world trip and is particularly inspired by Florence. His drawings are included in the group exhibition "Recent Drawings USA" at the Museum of Modern Art, New York. Awarded the 35th Annual

Art Directors' Club Award for his outstanding achievements (for the Miller shoe advertisement).

1957 Awarded a further prestigious prize for commercial artists, the Art Directors' Club Medal.

1960 Creates his first paintings based on comic strips (at the same time as Roy Lichtenstein is using comics). First two paintings of Coca Cola bottles.

1962 First traditional paintings on canvas of Campbell's soup tins (p. 31) and dollar bills (p. 23). First pictures using silk-screen process with Hollywood stars for subjects. Irving Blum of the Ferus Gallery, Los Angeles, exhibits 36 paintings of Campbell's soup tins, and buys them all himself.

Participates in one of most important Pop Art exhibitions "The New Realists" at the Sidney Janis Gallery, New York. First solo

Andy Warhol, 1964
Photo: Bob Adelman

Andy Warhol, 1941

exhibition of his paintings at the Eleanor Wards Stable Gallery, New York. Begins to produce the series of pictures based on catastrophes: *Car Crash* (pp. 51–53), *Suicide* and *Electric Chair* (pp.59–61). A rented attic, later famous as the Factory, becomes both workshop and home to a young and enthusiastic group of his helpers. A whole staff of workers is responsible for printing and often even carrying out every stage of producing works to his designs. Between 1962 and 1964 they produce over 2,000 pictures.

1963 Warhol makes the acquaintance of Gerard Malanga, who becomes his assistant. Start of his underground film production: first films *Sleep* (6 hours) and *Empire* (8 hours). In the following years he produces more than 75 films.

1964 First European solo exhibition in Paris branch of the Sonnabend Gallery, displaying his flower paintings (p. 42). The mural *Thirteen Most Wanted Men* at the New York State Pavilion has to be painted over for political reasons (pp. 62–65). First attempted "assassination" of Warhol paintings by a woman shooting at portraits of Marilyn Monroe. Produces his first sculptures: glued together silkscreen paintings of Brillo, Heinz and Del Monte packaging.

1965 First museum solo exhibition at the Institute of Contemporary Art, Philadelphia. Publicity proclaims he is giving up painting to concentrate on film making. Meets the rock band Velvet Underground.

Andy Warhol, 1968
Photo: Bob Adelman

Andy Warhol, 1974
Photo: Helmut Newton

1966–1968 Further films and collaboration with Velvet Underground. Leo Castelli exhibits the *Cow Wallpaper* (p. 75) and "Silver Pillows." The Factory moves into a different building.

1968 First museum exhibition in Europe at the Moderna Museet, Stockholm. On June 3 Warhol is shot by Valerie Solanis, only member of S.C.U.M. (Society for Cutting Up Men), and is badly injured.

1969 First edition of his magazine *Inter/View*.

1969–1972 During this period Warhol does relatively few works, commissioned portraits of artist friends and gallery owners (pp. 40, 41).

1972 With the series of portraits of Mao Tse-tung (pp. 70, 76, 77) he continues to produce pictures. From then on Warhol's work is punctuated by numerous commissions for portraits. Exhibition in the Kunstmuseum, Basle.

1975 Publication of *The Philosophy of Andy Warhol (From A to B and Back Again)*.

1976 The *Skulls*, and *Hammer and Sickle* (p. 82) series and portraits of Red Indian leader Russel Means are produced. The Württembergischer Kunstverein, Stuttgart, exhibits the first complete retrospective of his drawings.

1977 Produces the series *10 Athletes*. Exhibition of his folk art collection in the Museum of Modern Art, New York.

1978 A further large retrospective exhibition at the Kunsthaus, Zürich.

1979–1980 Exhibition of "Portraits of the Seventies" at the New York Whitney Museum. Creates the series *Reversals* (p. 17) and *Retrospectives* (p. 81), returning to the most important themes of his early works.

1980 Works on various video tape productions and on a private cable TV station, "Andy Warhol TV." *POPisms, The Warhol 60s* is published.

1982–1986 The series of catastrophe pictures; the pictures entitled *Myth* and the *Oxidations* series are shown at various exhibitions. Also produces a series using famous paintings as the theme: e.g. Johann Heinrich Wilhelm Tischbein's portrait of Goethe, Sandro Botticelli's *Birth of Venus*, Leonardo da Vinci's *The Annunciation* (p. 88) and *Last Supper* (p. 91) and Paolo Uccello's *George and the Dragon* (p. 89).

1986 The series of *Lenin* portraits and *Self-Portraits* prove to be his last.

1987 Andy Warhol dies on February 22 as a result of surgery.

Andy Warhol, February 1987
Photo: Bernd Klüser

95

My thanks are due to the following authors without whom I would have been lost in the jungle of facts and rumours concerning Andy Warhol's life. Their works are listed in chronological order according to the date of publication in the German language. The catalogue of the first European general exhibition entitled *Andy Warhol*, Stockholm 1968, included the commentary by Hans Georg Gmelin, "Andy Warhol und die amerikanische Gesellschaft."

Other books I have consulted include:

Rainer Crone: *Andy Warhol*, Hamburg 1970; Enno Patalas (ed.): *Andy Warhol und seine Filme*, Munich 1971; Rainer Crone and Wilfried Wigand: *Die revolutionäre Ästhetik Andy Warhols*, Darmstadt 1972; Württemberg art gallery catalogue: *Andy Warhol Das zeichnerische Werk 1942–1975*, Stuttgart 1976, with a detailed essay on Andy Warhol's philosophy, an interview with Philip Pearlstein, an essay by Nathan Gluck, and memoirs by Robert Lepper, Gerard Malanga and Henry Geldzahler and an essay by Tilman Osterwold. The Whitney Museum catalogue, New York, *Andy Warhol: Portraits of the 70s*, New York 1979, with an essay on Andy Warhol by Robert Rosenblum; Carter Ratcliff, *Andy Warhol*, Munich and Lucerne 1984; *Andy Warhol, Prints*, Munich 1985, with an introduction by Henry Geldzahler and an essay by Roberta Bernstein; Hamburg Museum catalogue: *Andy Warhol*, Hamburg 1987, with essays by Karl-Egon Vester and Janis Hendrickson, a very useful documentary synopsis by Janis Hendrickson and Mario Kramer and a memoir by Eva Windmöller; Werner Spies, *Andy Warhol, Cars, die letzten Bilder*, Stuttgart 1988, includes a detailed biography and reviews.

My thanks also go to Dr. Gail Kirkpatrick for giving me access to her study of Warhol in her unpublished dissertation. For reasons of space the other relevant books on the contemporary history of art and film which I have consulted must remain unmentioned. Further references can be found in my book *Kunst der Gegenwart (Contemporary Art)*.

Without Gabriele Honnef's assistance and her critical eye, inexcusable errors in the text itself could not have been avoided. Marion Eckart managed to convert my often chaotic dictation into legible copy. I am also obliged to the publisher for the excellent care taken in producing this book. KH

The publisher wishes to thank the museums, galleries, collectors, photographers and archives for their permission to reproduce illustrations:

The Thaddaeus Ropac Gallery, Salzburg; Neue Galerie – Ludwig Collection, Aachen; The Museum Ludwig, Cologne; Thomas Ammann Fine Arts KG, Zürich; Städtisches Museum Abteiberg, Mönchengladbach; Museum of Modern Art, Frankfurt am Main; Württembergischer Kunstverein, Stuttgart; Kunstmuseum Basel; Helmut Newton, Monte Carlo; Staatsgalerie Stuttgart; Bob Adelman, New York; Michael Becher, London.